ROCHDALE CANAL
John Evans

AMBERLEY

'The lock you have reopened will set free
The heart of England to the open sea'

John Betjeman, 1974

For Jane

First published 2023

Amberley Publishing
The Hill, Stroud
Gloucestershire, GL5 4EP

www.amberley-books.com

Copyright © John Evans, 2023

The right of John Evans to be identified as the
Author of this work has been asserted in accordance
with the Copyrights, Designs and Patents Act 1988.

ISBN 978 1 4456 9535 8 (print)
ISBN 978 1 4456 9536 5 (ebook)

British Library Cataloguing in Publication Data.
A catalogue record for this book is available from
the British Library.

Origination by Amberley Publishing.
Printed in the UK.

Introduction

People living alongside the derelict and overgrown Rochdale Canal in the 1960s had little doubt about its future. The historic waterway was defunct, just like the vast cotton and woollen mills that lined its banks. Its prospects were grim – it was little more than a memorial to industrialisation and human endeavour, destined to be a scar across both the landscape and the towns it once served.

Even though the power looms and steam engines of those mills brought prosperity, not everyone was convinced of their benefits. Charles Dickens labelled them 'fairey palaces' that emitted 'monstrous serpents of smoke' that led to many owners' greed and wealth, characteristics he personified in the arrogant capitalist mill owner Boundersby in *Hard Times*. Yet for a time the mills produced high employment and vital exports. They even gave women workers a career outside domestic service.

Many mills involved with textiles had a short life; less than fifty years was not unusual for those built during the early twentieth century due to imports making them uncompetitive. Then, like the Rochdale Canal itself, many survived to be reinvented. Those mills along the Rochdale now exist as storage, offices and apartments, a fascinating reincarnation inspired by the same rational thinking that once decided that their time was over.

Elsewhere in the country, revived canals had already shown their ability to regenerate the localities through which they passed. Why not the Rochdale, which had the advantage of penetrating beautiful hills and valleys, wild moorland and fascinating – if rather run-down – mill towns? All it needed was someone, or some people, to see the potential.

Step forward Brian Holden. Of course, it would be absurd to attribute the revival of the Rochdale to one man. The Inland Waterways Association vigorously opposed plans to legally abandon the canal in 1965 and the Rochdale Canal Society was formed to protect its route and to campaign for full reopening. But whenever conversations about the rebirth of this Pennine waterway take place, Brian Holden's name seems inseparable from the early days of practical pressure and political persuasion. His motto was 'never say never' and a memorial bench at Littleborough on the Rochdale Canal, provided by the Canal & River Trust (CRT) and Littleborough Civic Trust, honours his contribution. Brian, who died in 2018, passionately wanted the canal to be restored and knew how to get things moving.

And move they did, firstly on the eastern section between Todmorden and Hebden Bridge; little more than 5 miles long, it acted as a proof of concept as councils along the route worked harmoniously together in a way not always achieved by local authorities. The reinvigoration of the former mill town of Hebden Bridge started when the canal was reopened and other towns in the Calder Valley wanted to share the moment. Hebden Bridge attracted an influx of artists, musicians, New Age activists

and a thriving LGBT community. It also attracted people who wanted to open cafés, restaurants, quaint shops and market stalls, but most of all it attracted tourists. Thanks to Nigel and Susan Stevens, you could hire boats for a short holiday, and the reconstruction team built a wonderful new canal basin on the site of scruffy old buildings. It was like an advertisement for the opportunities that existed all along the canal.

Those involved in the building works, like Richard Booth and Nigel Lord, remember Brian Holden turning up to offer advice and encouragement. Rochdale, near his Littleborough home, was the site of a Manpower Services Commission canal restoration project way back in 1976, but it would be twenty-five years before a boater at Rochdale could sail on to the national canal system. Things really got underway when in 1983 and 1984 Calderdale Council seconded a small team to manage the eastern end of the project, paid for through Manpower Services Commission projects (i.e. the government) and using unemployed workers. This led to the reopening of the canal between Todmorden and Hebden.

They also created a lock-building operation (and later a business) at Callis Mill, near Hebden, which fabricated lock gates for much of the Rochdale Canal and eventually many others. It morphed into Hargreaves Lock Gates at Sowerby Bridge, which sadly closed in 2020. The detailed story of how the restoration was completed is well told by Keith Gibson in *Pennine Pioneer.*

During my research, I never stopped walking the towpath – most of it many, many times. I also took a boat on a trip thwarted at times by lack of water, a not uncommon problem. In fact, every Friday morning I stroll from Luddendenfoot along the canal for breakfast with a friend at Jo's Kitchen in Mytholmroyd. Suffice to say I never get tired of the walk, even after many years. It's what makes canals so attractive – every experience is different, including the people you meet, the weather and the things you see. In the end, I have tried to select pictures that tell a story, or are scenically attractive. My favourite spot is probably just west of the summit, where the fire-ravaged Rock Nook Mill stands sentinel over Lock 42 of the canal. What stories that sad building could tell.

The industrial archaeologist in me sees the grandeur of the vast mills east of Rochdale as being just as picturesque as the valley scenery and the wild summit. In fact, the canal divides neatly into two equally attractive sections. West of Rochdale it is mainly urban, with giant mills and enough locks to frighten even the most enthusiastic (and fit) skipper. East of Rochdale there are country mills, but it's really all about the Pennine views, with the Calder Valley hosting road, river, railway and canal as they compete for space.

So much was achieved, but it was a struggle. Writing in 1944 about the prospects for the English canal system, activist Tom Rolt was not optimistic.

'If the canals are left to the mercies of economists and scientific planners, before many years are past the last of them will become a weedy, stagnant ditch, and the bright boats will rot at the wharves, to

live on only in old men's memories.' Yet Tom had the foresight and perception to see an alternative. 'The canals can play their part not only as a means of transport, but part of an efficient system of land drainage and a source of beauty and pleasure.' He might well have been writing about the Rochdale.

If you are not familiar with the Rochdale Canal, I hope this volume will give you an introduction to the canal; should you be blessed with a home in its vicinity, perhaps some of Richard Booth's evocative photographs will help you to appreciate how it still might have been, were it not for people and – let's be fair – councils with great vision. I also try to show how the Canal & River Trust are working hard with limited budgets to make the canal a delight for current users and future generations. I have numbered all locks and bridges in the captions to help identify where the photographs were taken.

John Evans
Luddenden, West Yorkshire

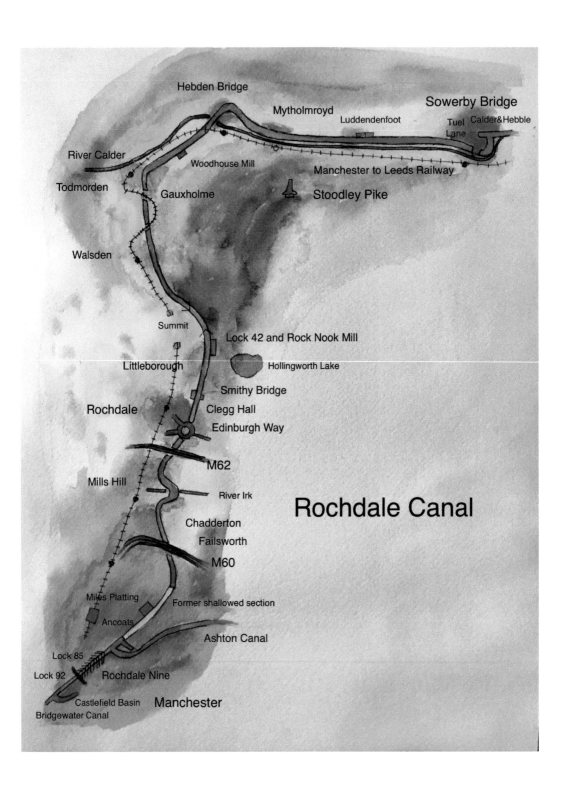

Hebden Bridge

Mytholmroyd

Luddendenfoot

Sowerby Bridge

Tuel Lane

Calder&Hebble

River Calder

Woodhouse Mill

Manchester to Leeds Railway

Todmorden

Gauxholme

Stoodley Pike

Walsden

Summit

Lock 42 and Rock Nook Mill

Littleborough

Hollingworth Lake

Smithy Bridge

Rochdale

Clegg Hall

Edinburgh Way

M62

Mills Hill

River Irk

Rochdale Canal

Chadderton

Failsworth

M60

Miles Platting

Former shallowed section

Ancoats

Ashton Canal

Lock 85

Lock 92

Rochdale Nine

Castlefield Basin

Manchester

Bridgewater Canal

Fly Boats and Water Worries

Market dynamics created the Rochdale Canal and 150 years later finished it off. Ironically, it was market dynamics that inspired its revival a further fifty years on.

The Rochdale was the first of three canals to cross the Pennines, the others being the Huddersfield Narrow to the south and the Leeds & Liverpool to the north. The Huddersfield Narrow bored expensively through the Pennines and the leisurely, lengthy Leeds & Liverpool took its time and wound its way around the hills. The businesslike Rochdale took the shortest route, climbing steeply over the moors. It shunned the idea of tunnels. From an initial concept in 1766, followed by debates about its route and width, there was a long pause until 1794 when an Act of Parliament authorised construction and at last building work started. 'It slept for twenty years,' wrote canal historian Charles Hadfield. There were all kinds of issues in pacifying land and mill owners, considering possible branches and links to other canals, plus the employment of three engineers (it was eventually built by one of the finest canal builders, William Jessop). It twice ran out of money, but was opened in 1804 after ten years of construction, beating its Pennine competitors. Building a canal over the hills meant lots of locks, some thirty-six heading to the summit from Sowerby Bridge and a mighty fifty-six more for boaters heading on to Manchester. At the time of its construction, it was one of the most ambitious canal projects in the UK. To save water, the locks had a standard rise of about 10 feet, which eased maintenance, as all gates were the same size. Once opened, it offered a much faster way of shifting goods than the weary packhorse with its single light load, which simply could not compete.

Of the three Pennine canals, the Rochdale was the most successful, striding confidently to an altitude of 600 feet over the hills. It firstly carried coal, grain and stone, plus cotton and wool, of course. Its wide beam boats with a capacity of 70 tons contrasted favourably with its narrow boat competitors on the Huddersfield Narrow, which held much smaller loads. It could even handle small sea-going vessels heading from Ireland to the Continent. At one stage it was so busy that eight 'fly-boats' – horse-drawn express freight boats operating to a timetable and having priority over other craft – were run every day from Rochdale to central Manchester, and you could get from Manchester to Todmorden in twelve hours with an experienced crew. There was even a fast local passenger service from Manchester in the early days. By 1839, some 875,000 tons of freight were recorded passing through Littleborough and the canal played a key part in the industrial development of Yorkshire and Lancashire. Who could have conceived that 10 years later it would be abandoned?

The Rochdale soon faced new forms of competition, firstly from the Manchester to Leeds railway, which ran alongside the canal for much of its length. The Rochdale Canal Company, which took over ownership of the canal, also ran its own carrying business. It kept investing in new, more efficient craft, at one time owning fifteen steam packets. Some services went right across the country, from the Humber to Manchester and Liverpool. Following the railway came the motor lorry, which dealt the death blow to the canal's prospects, and after 1921 it suffered a severe decline. Customers found new, faster and more convenient transport and by 1930 there were few through workings, most of the traffic being at the Manchester end. In 1937 the last loaded boats crossed the bleak summit. I'd like to have been on that final trip, the weary crew sweating their way uphill on a dying canal with the taint of war in the air. They probably had no idea their trip would not repeated for sixty-five years. The moribund Rochdale failed to become part of the nationalised British Waterways in 1948 as much of it was little more than a water channel. Apart from a short section of nine locks in Manchester (the 'Rochdale Nine') which allowed access to the Ashton Canal, the Rochdale Canal was formally abandoned in 1952. Once abandoned, the canal was subject to new low-level bridges being built across it and a large section was filled in near Miles Platting. It was now not navigable.

It then became enmeshed in the mania for canal restoration that commenced in the early 1970s – the Rochdale Canal Society was formed with the goal of reopening the whole canal. The Rochdale Canal Company still owned the canal while restoration was taking place. In 1965 the company tried to close the Rochdale Nine as well, as it was largely derelict. By then, the Inland Waterways Association, which had grown from a fledgling campaigning organisation in the early 1950s to a dynamic and very influential body, fought this vigorously as it was working to reopen the Cheshire Ring, which would require use of the Rochdale Nine to access the Ashton Canal. Yet restoration progress was patchy.

Longlees Lock at the east summit was restored by volunteers, but it was the participation of the local authorities through job creation schemes funded by the government that really achieved the canal's revival, starting in West Yorkshire.

Councillor Allen Brett became involved in 1989 when he was elected chairman of the Rochdale Canal Trust, a body formed by four councils: Manchester, Oldham, Rochdale and Calderdale. All saw the potential of the canal to provide a leisure facility and to attract economic revival – something that was already happening in Hebden Bridge through the reopening there a few years earlier. The bonding of these four councils and the later participation of the two strategic authorities, West Yorkshire and Greater Manchester, provided the impetus to overcome the main challenges. Principal among these were the proposed M66 (later M60) Manchester Ring Road at Chadderton, which would have obliterated part of the canal; the M62, which had simply chopped the canal in two; and

the huge new subterranean works needed in Sowerby Bridge to overcome a new road scheme. The political in-fighting one might have expected simply never happened.

'The councils have worked together brilliantly on this, and it has never been party political,' said Councillor Brett. 'We have always had all-party support. Everyone thought it was a good project and it had support from the general public. No one was against the restoration of the canal.' (Well, some farmers and, surprisingly, certain angling societies were, but that's another story.)

It was predicted that the canal's restoration would lead to visitors – local, day-trippers from the region and people from further afield stopping overnight. The councils hoped that new industrial and commercial development in Rochdale would appear, inspired by the rebuilt canal.

After many years' campaigning, the Rochdale Canal became the first major waterway restoration to receive a Millennium Lottery grant, which was vital to get the restoration finished. There was also funding from the government through English Partnerships, which understood the benefits the completely restored canal would offer. A charity called The Waterways Trust, funded by the nationalised British Waterways, took over ownership of the rebuilt canal from the Rochdale Canal Company and was appointed to complete the restoration and operate the waterway. Yet much work remained to be done. 'It was always so near yet so far,' wrote Keith Gibson.

Brian Holden, a driving force behind the revived canal and one of the first members of the Rochdale Canal Society when it was formed in 1974, told the *Manchester Evening News* in 2005 that the whole process had been about 'turning the tide' of dereliction. 'When councils blocked the canal, we called it official vandalism and there was more official vandalism on the Rochdale than anywhere else.' This included filling a long length in Manchester with concrete to make it safer for local residents.

A tribute to Brian on the *Canal World* website says: 'Without the determination of this one person, the Rochdale Canal would probably not yet have been restored.' Lock gate engineer Nigel Lord added: 'He was a fascinating character. He was a great lobbyist and Brian was very important to the success of the project. It was Brian, for example, who persuaded the councils that Tuel Lane Lock and tunnel should be built to accommodate 72 feet long boats instead of the 56 feet craft they originally proposed.'

'In the end,' said Nigel, 'the first section to be reopened showed how the canal could lift Hebden Bridge from being a dark mill town to a fascinating, rather bohemian tourist attraction. This showed the potential of the canal for regeneration for its whole length.'

A key victory for the project came in 1986 when the Department of Transport's public inquiry into the M66 ring road gave the green light to the canal's revival. The inspector was clearly impressed when

he visited the reopened section at Hebden Bridge, with the hire boat *Rochdale Pioneer* in use. Even though restoration sometimes seemed an impossibility, Brian Holden said he knew the canal would reopen when they won that public inquiry, adding: 'I felt sure that if I retired or died, the job would continue.'

A total of possibly more than £30 million was spent on the restoration. One of the most expensive single jobs, at £3.2 million, was the new M62 crossing, involving a new channel, bridge and a creative 'floating towpath'.

Other tasks remaining included six new bridges and a tunnel beneath the Edinburgh Way roundabout in Rochdale. There was also the small matter of a Co-op supermarket built across the canal at Failsworth, locks to be rebuilt and many other obstructions to navigation. The final challenges included building the new Tuel Lane Lock to enable craft to pass beneath a road development that had reduced the canal to a couple of water pipes and had eliminated two locks. 'A glorious new lock', trumpets the CRT website, and they are not guilty of hyperbole. This was opened on 3 May 1996, reconnecting the east end of the canal to the national network. Restoration work was then concentrated on some still closed western sections; when those in Manchester around Ancoats and Failsworth were finished, the scene was set for the first boats to make the entire journey once again. Having set a reopening date of 1 July 2002, it was all a bit fraught, but in the end the target date was met and once more, after some twenty years of endeavour, boats were able to cross the moors from end to end.

James Swindells was a British Waterways supervisor at the time of the reopening when boats made the first complete crossing. 'I recall that John Craven, the TV personality, was on our boat as we started from Castlefields in Manchester,' he said. 'With Derek Cochran, who was British Waterways North West regional manager, I steered the boat through the city and to areas we had restored using contractors and our own labour. It was a great personal pleasure to pass though Ancoats, where I grew up.' Ironically, as a boy he had helped to fill the derelict canal in.

'Our two boats, hired from Sowerby Bridge, travelled from Manchester to a ceremony at the M62 bridge where a group picture of engineers and workers took place. The boats then traversed the whole canal to Sowerby Bridge.'

To Live a Life

Waterways are living things. They change with the climate, nature and age. Most of us live a life – but the Rochdale has now lived two. Like most other canals, the Rochdale is now part of the Canal & River Trust, successor to British Waterways. Operating the canal is certainly not easy. Richard Parry, chief executive of the CRT, talked briefly about the Rochdale in an interview with YouTube's David Johns, who makes the popular Cruising the Cut videos.

'You open a restored canal and that is when the cost crystallises,' said Richard. 'The Rochdale and Huddersfield Narrow are amazing restorations, wonderful waterways, but they are very costly to care for because they were closed for such a long period. They were restored, but they still need decades of further investment to bring them up to a standard of reliability that people expect.'

Water has always been a problem, largely because of the huge number of locks over a relatively short distance. On average there are three locks for every mile. The Leeds & Liverpool has the same number of locks, but spread over four times the length of the thirsty Rochdale. Water supply on the Rochdale is also fickle – it once had seven reservoirs, but today there are just two. Hardly surprising therefore that in dry periods crews sometimes wait for days around the summit to get enough water. And yet there can often be too much water lower down, where it flows over the top of lock gates.

Hills and Mills – the Rochdale Canal from End to End

The canal clearly divides itself into two parts. The first is the country section from Sowerby Bridge to Rochdale, passing through mill towns and glorious countryside. The second, from Rochdale to Manchester, is much more urban, but hosts some of the most spectacular mills in the north-west and is a reminder of how the Industrial Revolution shaped the livelihoods of those who lived and worked alongside the canal. So let's take a journey along the Rochdale Canal. It begins at Sowerby Bridge.

Should you check out the Visit Calderdale website entry for Sowerby Bridge, you'll discover that the canal is featured prominently. It's here that the Rochdale Canal meets the Calder & Hebble Navigation, opened in 1770 and giving access to Hull, Wakefield, Leeds and routes to the south. The old wharf at Sowerby Bridge, where once goods were trans-shipped from the long 72-foot Rochdale Canal boats to the shorter craft designed for the Calder & Hebble's 57-foot-long locks, is dominated by beautifully restored warehouses. You'll also find the Shire Cruisers fleet with their distinctive geographical names based here. Cafés, pubs and shops are just a short stroll away and it's easy to see the revival that the canal has sparked in this area.

Leaving the wharf, the canal makes a long right turn and ascends through two locks before entering the curved tunnel, which passes beneath a major road junction. Christ Church looms impressively above and it feels as if you are about to float beneath its hallowed ground, but in fact the tunnel turns sharply left. The road junction was built while the canal was derelict, and severed the waterway, one of four Major Obstacles (capital letters are deliberate!) to reopening the Rochdale. At the end of the tunnel is Tuel Lane Lock, which has a rise of 6 metres and is the deepest in England, according to the CRT. The huge gates are manually operated by a lock keeper. It's a great place to while away an hour with a cup of coffee on a summer day, with plenty of good moorings for waiting boats. Replacing two previous locks (and given their numbers 3 and 4), this amazing lock was opened in May 1996 and completed the eastern part of the route.

The canal then passes thriving old mills on the left before striding out on a ledge through pleasant rural scenery as the Calder Valley opens up on either side. You might wonder if the canal is on an embankment or in a valley. Well, both answers are right. Near Bridge 5 there is an industrial estate, with the aptly named Secret Cafe and decent moorings. The next stretch to Luddendenfoot gives superb views to the south of green hills with Sowerby church perched on the top and heather-covered Midgley

Moor to the north. At Luddendenfoot, four-storey houses and a tall mill tower over the water with apparent frailty, as though they might topple into the canal at any moment. But already a pattern has been set, with the River Calder flowing just south of the canal, the Leeds to Manchester railway a hundred metres further on and the A646 trunk road a few steps north. There is one route through the hills, and all four methods of transport share the twisting valley floor.

The vista opens out on the next section, marked by the first locks since Sowerby Bridge and disused playing fields (after being flooded one too many times). At Moderna Bridge (9) the towpath detours over the top and then industrial units line the canal as we reach the centre of Mytholmroyd. The village is entered under an elegant bridge with a house standing precariously on it. Mytholmroyd boasts great coffee shops, restaurants, a handsome church with a spectacular interior, fast food outlets, and a couple of supermarkets.

The wide valley views continue on the next stretch to Hebden Bridge, an enchanting market town with lots of pubs and restaurants, a neat little cinema and a theatre, plus excellent small shops that helped it win a Great British High Street Award a few years ago. You will pass a long line of house boats on your way into Hebden, and it's definitely worth a stop. On the right is the marina, built when the canal was reopened. In both Hebden Bridge and Stubbing Wharf, a short distance further on, you can take boat trips or hire day boats. Like much of this part of the canal, there are many excellent walks.

We are now on the first section of canal to be reopened, in May 1983. The canal passes over an impressive aqueduct and then boaters need to prepare for an arduous run of some twenty-six locks in fewer than 10 miles as the waterway clambers up to its 600-feet-high summit. If you think the tall chimney ahead of you is leaning slightly, it's because, according to local folk, it is! Once the canal has passed beneath the Whiteley Arches railway bridge and the Pennine Way long-distance footpath, it reaches Callis Lock, where once the workshops fabricated lock gates by the dozen to restore the canal. Sadly, the building is now a roofless shell. To the left, high on the hills, stands Stoodley Pike, glimpses of which can be seen all the way from Mytholmroyd to Todmorden. It is 120 feet high and commemorates the defeat of Napoleon in 1814, although it has been much rebuilt since.

The canal now enters a wooded section with road, railway, river and canal still competing for the narrow space, before widening to give much more open vistas. We pass the impressive Woodhouse Mill, once a worsted mill with a central hoist for loading boats. In 1863 there was a boiler explosion here – a 'horrid roar' according to the *Halifax Guardian* – and a woman employee named Sarah Greenwood was killed. After being virtually destroyed by fire in 1994, it was comprehensively rebuilt and now survives as apartments. There are excellent moorings on this stretch with views guaranteed to get you on the move after an overnight stop.

From locks 14 to 17, the tree-shrouded valley is especially attractive. The approach to Todmorden is through wooded hills and stone cottages, before the canal enters the built-up area, with a boat selling excellent coffee by the towpath. It is here that the River Calder leaves us, working its way north-west towards the Burnley direction and its source in the hills above Todmorden.

Todmorden is an increasingly attractive market town with splendid buildings and an imperious town hall watching over the whole of the conurbation. It appears to have been built around the canal, which has been driven right through the centre, with a guillotine lock next to the main A6033 road. A horse tunnel passes beneath the road. As if competing for prominence, the railway strides across the town on a magnificent stone viaduct. Interesting shops of all kinds, plus plenty of independent cafés, bars and restaurants make it a great overnight or day stopping point, with more good moorings. It also marks a change of direction – the canal switches from its westerly heading to south. As you leave Todmorden, you can't miss the so-called 'Great Wall of Tod' – a vast brick structure that protects the canal from the railway above. Notice that it has no supporting buttresses. It was built in 1881.

Travellers by road from here to the summit will note how steeply you seem to be climbing. Yet alongside is the canal, never more than a short stroll away and keeping pace with the uncompromising climb. The railway runs out of steam near the summit and passes through a tunnel, but the canal has no such qualms and just keeps on ascending. As the canal climbs, the landscape seems to change, becoming more rugged with heather and gorse bushes. You will soon see the railway viaduct at Gauxholme, with its castellated towers and built at an acute angle across the canal. After a couple of locks, the railway recrosses the canal, this time on a less extravagant bridge. The canal continues climbing through Walsden, where St Peter's Church and its sharply pointed spire can be seen for quite a time on our journey. Once yet another busy mill town, Walsden is now a useful stopping point with a post office, railway station, shops and pubs. Nip Square Lock (29) is Grade II listed, due to its retaining walls. It is one of a series of locks, commencing with Hollins Lock (27), which provide a strenuous challenge to boaters. After a short respite at Warland the climb starts again, this time right to the summit. This is a very attractive area, with sturdy moorland views to the east and hills that sweep down to the canal. Look out for alpacas at a canal-side farm here and enjoy a perfect scenic setting at Lightbank Lock (31). Soon we see a boundary post marking the move from Yorkshire into Lancashire. Longlees Lock (34) is the last one before the summit. You have reached the highest point, but don't be fooled into thinking you are halfway to Manchester. Lock 34 was restored by enthusiasts from the Rochdale Canal Society in 1980. Isolated at the time, it was nevertheless the scene of a dinghy rally in 1980. The short summit pound passes a village appropriately named Summit on the nearby road, with a pub and

shops. This is a wild, sparse and desolate place, not lacking grandeur, but you can well believe stories of boats in the olden days being trapped by ice for days on end in winter. Author Ray Quinlan wrote about walking on this section in 1993 while it was closed.

'The summit pound was just a trickle,' he said. 'The mud at the bottom was littered with miscellaneous debris including the bones of a narrow boat and a tub-boat.' But his enthusiasm shone through. 'It's enough to make even the most fervent canal-hater put on their walking boots,' he wrote.

Things are even better today, but the summit area is still one for boaters to treat cautiously. While researching this book I met several crews who had been trapped near the summit through water shortages. Once over the summit you pass West Summit Lock (37) and it was here that feeders from the Chelburn Reservoirs, high up on Blackstone Edge, supplied the canal with water. The Rochdale was once topped up by seven reservoirs, including Hollingworth Lake some 4 miles away (where a steam pump was used to move water to the canal). This lake is worth a detour – it was built as the main water supply for the canal, but from 1860 became an increasingly attractive tourist destination, a role it still fulfils. Back in the 1860s there were steamers on this lake. When the steam pump was abandoned in 1857, the water was diverted to feed the canal at Littleborough by gravity. The Rochdale Canal Company sold the reservoirs to Oldham and Rochdale Corporations for water supply in 1923 when canal trade was rapidly declining. A clause made provision for water supplies to the canal to continue by retaining just one of the Chelburn reservoirs, but this simply isn't enough, especially in a dry period.

At the summit, the valley scenery that has been with us since Sowerby Bridge changes. From here to Rochdale we see undulating hills, but greener, less gritty and more urban. The railway rejoins us after its one-and-a-half-mile hibernation and you can see the tunnel entrance near Punchbowl Locks (40–42). Our minds might well be distracted by a forbidding, looming shape ahead on the east side of the canal. This is a dramatic mill, blackened and stained, yet heroic in its presence and still a thing of uncanny beauty. 'Dark and satanic,' suggested Quinlan in his 1993 walking guide. Rock Nook Mill, like Woodhouse before it, suffered a fire – probably arson. It destroyed the roof and top floor in 2015, but its close proximity to Lock 42 and the way it towers overhead make it a sinister and spooky companion. A creepy and highly ill-advised walk around its ruins can be found on YouTube. Once the property of Fothergill and Harvey, who later became part of Courtaulds, it was built in 1886 from stone. You can still find office desks and all the other paraphernalia of everyday business life inside, all covered in filth and ashes. In fact, this company built across the canal when it was closed, developments that had to be removed when it was reopened. Punchbowl Lock (40) was filled in and a car park built over it.

After Pike House Lock (45) there is a short respite from the continuous locks for boaters. Littleborough comes next, a pleasant little mill town with the requisite railway station, shops and cafés in a moorland setting. Its handsome architecture makes Littleborough worth a stop. We have now reached our first town in Greater Manchester, although there is plenty of work to do before we reach the centre of the city. In an excellent second-hand bookshop here, I picked up three old books about canals in the north for a few pounds from a proprietor who really knew his stock. From Littleborough the canal passes beneath a couple of pipe bridges before arriving at the small community of Smithy Bridge (which nevertheless boasts a railway station). 'Change here for Hollingworth Lake' might have been announced in the old days.

Bridge 54A is a neat swing bridge, one of several on the canal, which stands at the end of an attractive terrace of stone-built houses. Now the canal swings right and two handsome buildings can be seen on the east bank of the canal. One is Clegg Hall, a nicely symmetrical seventeenth-century mansion that is reputed to be haunted. This was yet another fire casualty, this time in the 1950s, but it has now been restored to its 1605 condition. A truly remarkable project. Next door is Clegg Hall Mill, yet another fire victim. This has also been superbly rebuilt from a shattered ruin to provide elegant apartments.

Boaters can take a real breather on this section as the 4-mile stretch from Lock 48 in Littleborough to Rochdale, where you encounter 49 and 50, is lock-free. The outskirts of Rochdale soon appear. Around here there is a visual change that becomes very noticeable as we proceed towards Manchester – the mills are built from red brick rather than stone and tend to be much bigger and rather more extravagantly designed, even though those that remain have mainly been converted for other uses.

One sign of modernisation is the tram route, once a full-blown railway, that passes over the canal just north of Rochdale and heads to Oldham and Manchester. Rochdale displays its heritage in the first of several huge mills, this being Moss Mill, now industrial units. After that we pass locks 49 and 50, where on one of my trips on the canal I met a very enthusiastic group of volunteers clearing rubbish and pruning undergrowth.

'We work with a CRT colleague,' one of them told me. 'Rochdale doesn't have a great reputation as a safe place for overnight moorings. This is one step to change that.' Rochdale is a real canal town and has so much potential. An arm from the canal used to run right through to the centre and traces of it still remain. A ten-minute walk takes you to the tram and railway interchange and a further few minutes to the main shopping area.

If, like me, you are fascinated by industrial archaeology, the route from Rochdale to Dale Street in Manchester will provide endless visual entertainment. Those who have cruised from Sowerby Bridge may feel they have broken the back of the journey ... well, they have, but only just. There are more than forty locks remaining!

Any pretense of a rural environment is now lost as we head for Mills Hill on a few miles of canal that offered the biggest obstacles to its reopening. It all starts innocuously enough, as the canal makes its way out of Rochdale through a none-too-pretty area with graffiti and litter as companions. Then comes the second Major Obstacle for the canal restorers (counting Tuel Lane as the first). A major intersection and roundabout called Edinburgh Way stands right in the path of the canal and walkers or cyclists have to leave the towpath, follow signs across the roads and skirt round a BMW car dealer to rejoin the towpath. The canal burrows its way beneath the roundabout. Ahead lies Arrow Mill, now used for storage, with writing on the chimney. This is great, because I like chimneys that have signs on them and, anyway, all too many chimneys have been felled. This textile mill was one of the last still working (until 1999) and is notable for its Byzantine-style water tower. By being built alongside the canal, the mills obviously had instant access to transport, but as most were once powered by steam, there was also a ready supply of water for boilers.

With more red brick industrial buildings alongside us, the canal curves left through Castleton and Blue Pits locks (51 and 52) before reaching Major Obstacle number three for the restorers. This is the M62 motorway, which was built right across the derelict canal, chopping it in two. Old maps (in those books I picked up at Littleborough) show two ends bluntly stopping as the M62 motorway sweeps through. Rather than trying to build a new bridge, which would have caused chaos and proved horrendously expensive, an old culvert was used. It was expanded and the canal diverted through it, with Lock 53 moved to maintain the water at the right level. The tunnel can even accommodate wide beam boats, as there is a clever floating towpath that allows narrow boats to pass, but can be moved to allow entry to wider craft.

We experience a degree of country air and an enticing-looking pub at Slattocks, but undoubtedly boaters will be looking at the six closely spaced Laneside locks (54–59). The railway to Manchester sweeps overhead on a rugged but elegant span (68B) and then recrosses the canal on a decorated steel bridge on the outskirts of Chadderton. Now the canal makes a river-like 180-degree bend to avoid high ground, and crosses the River Irk on a rather unimpressive aqueduct. All of a sudden, the canal enters Chadderton, part of Oldham, and we will be in built-up areas to the end of our journey. Malta Mill comes next and was one of many built in the early years of the twentieth century, its design being rather less flamboyant than some others. Kay Lane Lock (64) was being rebuilt on one of my walks and I was amazed at the amount of scaffolding and building materials needed. A short distance further on we come to a lifting bridge, the only one on the canal (75A).

Major Obstacle number four, and the one with the most dramatic solution, was the M60 motorway. The Rochdale Canal Society diligently battled for a public inquiry into the route, which resulted in a major

piece of infrastructure as a new length of canal now passes beneath a motorway junction. The waterway dives underground while the towpath heads uphill, this time crossing the M60 on a lengthy glazed bridge, before returning back to being a canal-side towpath. After another tram crossing, we see Ivy Mill with its rather truncated chimney (at Lock 65). This is a length of canal where the water shields itself from the surroundings to some degree by trees and a cutting, but at Bridge 78C the canal widens with a mix of traditional and new developments. It's fascinating to look back at books written when the canal was closed. 'At Failsworth a large shopping development has been built across the canal line,' writes John Lower in 1998. 'Restoration proposals show a new route built through the narrowest section of the building.' Well, that didn't happen, but the obstacle *was* removed.

Our next mill is Regent Mill, again built during mill mania in 1905. Although it lost its chimney back in 1964, it's a splendid building now used by Russell Hobbs. After Tannersfield Highest Lock (66) comes yet another mill, with a newish supermarket facing the canal built in the same architectural style. Evidence of the scale of work required to rebuild the canal can be seen everywhere in this area, with new bridges and resurfaced towpaths. Here on one walk I saw the crew of a Canal & River Trust boat aground right in the middle of the canal. We all (including the crew) saw the funny side of it and help was on its way.

Bridges and locks come every few metres as the canal begins an almost desperate descent through Newton Heath, with its mix of housing and pleasant tree-lined towpaths. You could almost be in the countryside at times, but a glance at the map shows that we are encased by Manchester. Pinfold Lock (70) is particularly interesting with its short balance beams operated by a chain system. This section was filled in around 1970 with concrete ('shallowed') to form a safer area for residents of new housing developments. Presumably a restored canal is much safer than a derelict one, but removing the filling was a huge job. Near Lock 77 the canal runs in a concrete channel, and ahead we get our first look at possibly the most magnificent building on the canal, Victoria Mill at Miles Platting. Its distinctive octagonal chimney appears to rise out of the middle of the mill. It worked until 1960, but is now offices and housing.

Modern apartments show we are entering the heart of Manchester and soon we come to New Islington Marina with its trendy housing, bars and new moorings. It's an ideal place to stop and have a well-earned glass of something while preparing for the final descent into Manchester ... or perhaps to celebrate the accomplishment of climbing out of the city centre. Right by Lock 82 is Royal Mill, a splendid towering building now converted to apartments. The happy little red Kitty Footbridge by the side of it (88a) means we have reached Ancoats and the last stretch of the journey through the reinvigorated city. There never seems to be a time when you visit Manchester without seeing cranes sprawling up above the

skyline. At Lock 83, part of the impressive Brownsfield Mill was once an early aircraft factory.

Ducie Street Junction gives access to the Ashton Canal, a vital link in the north-west canal network, but then we start to descend through the final nine locks, the famous 'Rochdale Nine', the first being Dale Street (84). Painted bridges, mills, striking modern buildings and locks follow in quick succession, with a small exclusive-looking wharf to our right surrounded by new apartments. Without the need for a sign, it shouts 'Private - Do Not Enter.' Lock 85 is in a tunnel beneath Piccadilly and is probably the least pleasant place on the whole canal. The canal emerges from the tunnel on its final gentle curve through Manchester's Gay Village, where the towpath disappears for a few minutes and you have to walk along Canal Street, with its mass of bars and clubs.

'Do you get much business from canal users?' I asked the owner of one of the gay bars. 'Not really, because there are simply no moorings here,' he replied. 'But it is essential to the character of the bars in Canal Street – people just love to sit outside by the water, especially when boats go by.'

At Lock 86, the old lock keeper's house is situated above the canal, while Oxford Street Lock (88) is in a claustrophobic setting with towering offices above. After the dank Deansgate Tunnel, the railway becomes a dominating presence, crossing the Rochdale on a colourful arched bridge and then running alongside the canal on a massive brick viaduct for its final few hundred yards. Andrew Crowther's grim pictures of this area fifty years ago, which I have reproduced, show an unbelievable change since then. Even today litter is a major problem for the canal. *The Guardian* reported in 2015 how a safe full of money had been dumped in the water. Nobody claimed it, so it went to the canal society. The end of the canal is actually rather ignominious – it pops out of the small Castle Street bridge (101), just after Dukes Lock (92) into Castlefields Basin, right in the heart of Manchester. If you have reached here from Sowerby Bridge – excellent. If you are about to leave here for Sowerby Bridge, well, a lot of work lies ahead. But it is more than worth it.

In the Beginning...

Richard Booth was project engineer for the canal east of the summit. He has fond memories of his time restoring the Rochdale Canal.

'In April 1982 the local council urgently needed a scheme to engage the rapidly-increasing numbers of unemployed people,' he said. 'It was run by a government organisation called the Manpower Services Commission (MSC). The idea was that the MSC would pay wages to long-term, unemployed people who would be recruited for local authority community projects.

'Anyone who has come into contact with an MSC scheme will be aware of the difficulties associated with managing a workforce governed by stringent regulations designed in Whitehall with the aim of reducing the numbers of jobless people. Not exactly the ideal preconditions for starting a new direct labour organisation.'

Nevertheless, Calderdale Council had an idea that seemed to tick all the boxes. The plan was to restore 5 miles of canal between Todmorden and Hebden Bridge, including twelve locks, using fifty people, most of them working part-time. All were drawn from the unemployment register with no more than a casual interest in canals. The project was to last two years and the goal was to enable boats to operate between the two towns.

'Restoration proceeded steadily, assisted greatly by all the original lock chambers being intact and in surprisingly good condition,' said Richard.

'It should be remembered that the last end-to-end trip between Sowerby Bridge and Manchester had been made in 1937, and photos of the canal in Calderdale showed parts of it completely overgrown with just a trickle of water, but elsewhere with rather more water and the towpath still in use by walkers.

'Standing in a newly-restored lock surrounded by a thousand tons of huge millstone grit blocks, everything two hundred years old, was quite an experience. Seeing the individual stonemasons' marks on each stone makes one wonder how on earth the navvies built fifty such locks in four years with only hand tools.

'The fact that old drawings for many of the lock gates still existed helped the restoration enormously. Fish were removed to a new location under the supervision of a fisheries officer when parts of the canal were drained. Useful notes pencilled on the original drawings helped us – "these gates would have been better one inch wider at the top," for example. Someone obviously thought the gates would be replaced one day.

'The new workshop established at Callis Mill in Hebden Bridge produced, in eight years, nearly 200 lock gates plus other items including footbridges. Wherever possible, original ironwork and gears were reused. The bottom lock gates were usually found dumped inside the lock, stripped of ironwork which had presumably been stolen for scrap. The loss of these gate paddles added £40,000 to the restoration bill. All items except the castings were made at Callis, including footbridges, mooring

points, metalwork and the renovation of a fifty-year-old narrow boat for our use in maintenance work. Gates for the Huddersfield Narrow Canal, being restored at the same time, were also built and fitted by the team.

'The walls of the locks were no longer watertight so complete grouting of the lock walls became the norm. At one lock it took 75 tons of sand and cement to seal the chamber and in another the wall appeared to have actually moved. Strange items were found in the locks, which included dummy bombs that had to be removed by the army's bomb squad.

'When a canal runs through a valley, it causes another restoration problem. Some forty years of silt had gradually moved down the valley sides and ended up in the canal to become the biggest problem for the restorers. Some 300,000 tons had to be removed and in some places it was four feet deep. Operating a fleet of dumper trucks along a narrow towpath driven by a group of budding Lewis Hamiltons helped to turn my hair grey!

'At its maximum, one hundred workers were employed and this enabled extra jobs to be accomplished, such as recreating the canal basin at Hebden Bridge.

'Calderdale Council refused to let the eventual demise of the MSC schemes halt the restoration. A small team of skilled workers carried on the task to completion, and then handled improvement and maintenance of the 13 miles of canal in the council's area.

'Everyone looked forward to the order for the huge gates at Tuel Lane, which eventually meant the completion of the Rochdale Canal in Calderdale, and a vital link to the rest of the national canal network,' added Richard.

Nigel Lord, who joined Richard Booth's team in the early days at Callis Mill and later became manager, said he was recruited because his background was in pattern making. 'Right from the start Calderdale Council saw value in the canal restoration,' said Nigel.

'I was very happy to be involved with this. In fact I looked forward to work every day. Thirty years later I was still there! We were simply a team of lock gate makers and we were building individual gates for each lock.

'Some of these old gates were still in remarkably good condition, a tribute to the people who originally built them, although obviously they could not be used again. The actual lock chambers were in quite good condition really, despite not having seen boats for many years. Yet once we put water in the chambers, it just ran away, because they had not held water for so many years. Eventually we made them pretty watertight. Richard Booth kept a diary every day of what was happening and so did I.

'When the canal was abandoned, many of the locks had concrete weirs installed so water just ran into the lock and straight out again where the missing gates had been. Basically, the water cascaded downhill from the summit until it reached Sowerby Bridge and the Calder & Hebble Navigation, which was still open. I have to say that back in those days

we were able to do things much faster than would be the case today, with more stringent health and safety legislation.

'I think we were very successful. You have to remember we were using long-term unemployed people, some of whom couldn't be bothered to get up in the morning. I found it most enjoyable, if difficult, to work with them. They had good supervisors who were passionate about the project and this fed through to the lads we used on the MSC scheme.

'There was continual pressure on the local authorities to open more and more of the canal. Eventually the councils handed over the project to British Waterways. I started a new company called Hargreaves Lock Gates in partnership with Hargreaves Foundry Ltd once the MSC project at Callis was finished. This business is in my blood.

'There were so many problems with the Tuel Lane project in Sowerby Bridge that for a long time we thought it would never happen. It would mean our new canal would never be connected to the rest of the system. But it happened and the huge lock gates at Tuel Lane were made at Callis. The timber we used is very dense and it is as good today as it was 20 years ago. There have been no problems with it. We also made most of the gates at the Manchester end.'

'She was Terrified!'

'You definitely do not want to walk through there,' said a tall woman clutching a lock windlass. She emerged from the gloom of the tunnel that burrows beneath Piccadilly, in central Manchester, to prepare the next lock for the arrival of her boat. It was my first time at Lock 85.

I could see a walkway disappearing into the tunnel, with lighting either side. A minute later my mind was made up. A young guy came out of the tunnel looking worried. 'Don't go in there,' he said. 'There are unspeakable things happening.'

But this is a sunny afternoon in mid-March. Can it really be that bad? Another glance at his face and I followed him off the canal, where he gave me a diversion over city streets. I knew from what I had seen and read that the tunnel under Piccadilly could at times be an unsavoury, even dangerous place, but surely not today? Buried beneath the massive columns that support the buildings above lies Lock 85, and as plenty of YouTube vlogs have attested, sinister people, drug dealers and worse can make life menacing for boaters and walkers.

Boaters, of course, have no choice and must spend fifteen minutes or more grappling with the lock. It's not the fault of the canal. On occasions I have strolled through with no issues, watching boaters calmly working the lock observed by a few men minding their own business.

Lock 85 is part of the Rochdale Nine, a flight of locks that climb out of Castlefields Basin and give boaters a wearying challenge. Many carry on through two more locks, reaching the security and fresh modernity of New Islington Marina with its excellent moorings and attractive surroundings. I couldn't resist asking the CRT about the rather sinister Lock 85, and was pleasantly surprised to hear that a public consultation about this is (at the time of writing) being held.

'The CRT recognises that the area needs work and investment, but also that the undercroft has masses of potential to be so much more than what it is currently,' said Leon Edmonson, the CRT's Area Operations Manager. The CRT has published an excellent consultation document that admits the environment is 'unwelcoming' and 'challenging' but adds: 'We want to find answers to these challenges though, and there's plenty of potential in this place to take inspiration from.'

The sadness of Lock 85 is that it is close to so many wonderful buildings, modern hotels, the rejuvenated Gay Village and huge mills converted to modern apartment living. This is the potential that it is intended to exploit.

A guy working in a bar nearby told me of the time he took his new girlfriend for a romantic canal walk one winter evening that included Lock 85's gloomy tunnel. 'Was everything okay?' I asked. 'No,' he replied. 'She was terrified!' Happily, it seems, the new determination to improve the area means things are about to change for the better as, incredibly, since 1994 Lock 85 has been a National Heritage Grade II listed building.

Whatever Floats your Boat

'Don't you just love it when a plan comes together?' Those who remember the *A-Team* TV show from the 1980s might be surprised to hear that this quote from 'Hannibal' Smith equally applies to a small boat hire company in Sowerby Bridge. Small? Well, not so much these days, when Shire Cruisers are stars of television, YouTube and the Yorkshire canals. But back in 1980, when Nigel and Susan Stevens bought the business, they could only look eastwards to the river navigations of the West Riding. 'Reopening the Rochdale Canal throughout seemed impossible at the time,' said Susan. 'We just knew it couldn't be done.'

Nigel described how the Rochdale Canal appeared in the 1980s. 'It was in a very sad condition. The section around Sowerby Bridge, for example, was full of rubbish and the locks had their gates removed so the water just flowed over concrete weirs. And much of the canal at Sowerby Bridge had been filled in during the 1960s.

'The campaign led by the Rochdale Canal Society achieved the reopening because it was the right thing to do. Susan and I had for a long time been part of the movement to restore canals, but we knew that getting the Rochdale reopened meant having the project taken seriously by decision-makers. As work progressed, it kept getting good publicity and, in the end, the massive hurdle of constructing the new Tuel Lane lock just seemed a natural progression.

'They did it very well and with no fuss,' said Nigel. 'Getting the politics right was vital, but the will to reopen the whole canal was always there. Calderdale Council is only a small authority, but it has the longest part of the canal and early on became determined to restore its whole length, with Adrian Rose and Richard Booth from the council together being the driving force.'

'Once the canal was rebuilt from Todmorden to Hebden Bridge, John Sully (then a county councillor whose committee funded pivotal parts of the restoration) suggested we should put a boat on it, first *Rochdale Pioneer* and then *Rochdale Progress*,' said Susan. 'That part of the canal was isolated, but it did include some very attractive scenery.'

Nigel added: 'This small enterprise came into its own during the public enquiry into the M60 motorway construction. They wanted basically to obliterate the canal, but by having a boat elsewhere on the Rochdale, we showed the canal was alive. It led to a thousand metres of new construction, so the waterway could pass beneath the new motorway.'

Today Nigel and Susan see the joy of the reopened canal in the way it belongs to so many people.

'They see it as *their* canal,' said Susan. 'Having a boat at Hebden Bridge gave the community some of its pride back. With the canal fully reopened, the town is so much more than it once was.'

Boat hirers of all kinds come to explore the Rochdale Canal – from all around the UK and, indeed, all around the world. Young families are an increasingly important group and Nigel and Susan also recognise that seeing their beautiful narrow boats on television crewed by Timothy West and Prunella Scales was a real boost for their business.

Of course, the canal can be a challenge for boat crews. 'Hills equal locks. It is physically demanding. You cannot have these lovely views without spending money to make the locks better. And money follows boats, which means most of it gets spent well south of here, where there are lots more boats,' added Susan.

'There are also water supply problems if the weather is dry. The Rochdale is reservoir-fed, but there can be insufficient water. The CRT are very good at managing it, but we really need to get a set amount of water each week.'

Despite a few problems, Nigel is unerringly positive: 'The canal is scenically brilliant. There is a big explosion in the number of people buying boats and the future is definitely bright.'

If at first...

Experienced boater Barney Bardsley has been sailing the Rochdale since the 1970s and is nothing if not persistent. I met him on the Rochdale Nine.

'I first attempted the Rochdale Nine in 1975 when the canal was owned by the Rochdale Canal Company and you had to pay for a passage,' he said. 'And they were not really encouraging passages. We were on the Ashton Canal and rang to make sure we could pass though the locks to get into Manchester, but they were simply not allowing passages so we had to turn round and go back.

'We subsequently tried again in 1977 and did manage to get through. This cost us £10! The Ashton Canal and the Cheshire Ring were open then, but the rest of the Rochdale Canal, apart from the Nine, was closed. Even the Nine were in appalling condition. The balance beams on some of the locks were broken so you could only use one gate.

'As now, there was far too much water on the Rochdale Nine and water was flowing over the tops of the lock gates so they were very difficult to open. At one lock, two very strong lads jumped over a wall and between us we managed to open the gate.

'My first try at the whole of the Rochdale when it was reopened was unsuccessful as one of the summit locks had been vandalised. The gate beam had been cut off with a chain saw. Later, we came back and got through and it is a brilliant canal because of the amazing scenery, especially the Yorkshire side.'

I left Barney grappling with a lock that had been mysteriously padlocked, although a CRT man soon came along and saved the day.

The Chelburn Challenge

The formidable task of managing and maintaining the canal falls to the Canal & River Trust, with Victoria Levine being Area Operations Manager for the east side (locks 1 to 33) and Leon Edmonson Area Operations Manager for the west side (locks 34 to 92). 'The Rochdale is an extremely challenging canal in a multitude of ways,' said Leon. 'However, because it is so challenging it is also extremely rewarding when you begin to implement changes and see all the positive work we plan come to fruition.'

Two external suppliers provide the water for the canal – United Utilties-owned Chelburn Reservoir supplies both east and west sides, while Hollingworth Lake provides extra water for the west side. The amount of water that the CRT is entitled to use is regulated by season, with obviously more in the summer. The Trust works closely with United Utilities to ensure allowances are not exceeded and reservoir levels are maintained, which causes problems during prolonged spells of dry weather.

'Ideally, the water is split evenly between the east and west side, but occasionally either side may need to draw water from the summit pound to keep lower pounds in water,' said Leon. A long dry spring and summer, like that in 2022, affects all the nation's water and the CRT, which needs water to maintain its rivers and canals, is heavily into water management. 'We had to close the Rochdale from Lock 1 to Lock 45 due to water shortages that summer because supplies were not being replenished,' explained Leon. Arrangements were made so boaters could find a suitable place to moor for a number of weeks and then the east section was closed.

'We made this decision because we felt we didn't want to put boats, wildlife and ecologies at risk by drawing pounds down to levels which were unnavigable for sailing and dangerous for fish and habitats,' said Leon. Weekly resource meetings keep an eye on the position and decide what action is required.'

Two CRT staff members look after water control – keeping pounds full, clearing grilles of rubbish to make sure water flows efficiently, helping boaters so they don't have problems navigating the waterway, removing debris on the surface and dealing with other work that may arise. Each section of the canal presents different problems.

'The more urban communities naturally bring with them vandalism, anti-social behaviour and fly tipping. Typical problems may be youths who have acquired a windlass running water from pounds until they are empty, stolen cars and motorbikes in the canal, fly tipping and vandalism of assets and property. However, it needs to be said that the canal has improved in all of these areas in recent years and the problems are becoming less and less frequent.

'They are still an issue, but as the years pass by communities seem to be taking more pride in the canal corridor. Certain parts of the Rochdale Canal still have a reputation of an anti-social nature, but this is more

remnants of times gone by. The CRT continues to work on community engagement and perseveres with keeping the canal clean, green and safe to ensure that visitors have a great experience each time they visit.

'Another challenge is that the canal was restored just over 20 years ago and, as a lot of assets were replaced at the same (or a similar) time, naturally, they begin to expire at a similar time. As a charity, our funds are limited so we need to ensure that we prioritise work as efficiently as possible in order to rectify the problems which need the most attention.' Lock gates, for example, usually last twenty to thirty years and are regularly inspected and maintenance included in the appropriate business plan.

Leon also revealed that the CRT team are dedicated to enhancing the heritage and operation of the Rochdale. The local team are continually trying to improve the canal, while Newton Heath, Chadderton and Littleborough all have volunteer task forces that were formed on the basis of people wanting to maintain the canal and the communities it passes through.

'CRT's own engagement and enterprise teams are constantly working on engagement and funding opportunities to ensure the canal is kept in the best condition possible,' added Leon. 'But all of this is a work in progress and cannot be done overnight. We have long- and short-term visions which all aim towards one thing: making the canal safe, open and accessible, clean and green.'

How to Save a Life

It is tempting to think that once the canal was reopened, it would settle down to a life of tranquility. The drama and challenges of creating a revived artery from Sowerby Bridge to Manchester were over – ahead lay an aura of calm repose as a place where exercise, boating skills and the fascination of nature would be the new norm. But waterways were never that way. Where there is water, there is the potential for catastrophe. At Coney Green Lock (62), at Middleton, red warning signs tell a tale of tragedy. 'No Swimming' they proclaim and adjacent is a large board to which is affixed an emergency throw-line to be used in rescuing anyone unfortunate enough either to fall in, or who foolishly goes for a swim. The throw-line is dedicated to a thirteen-year-old boy who lost his life in the lock in 2016. Such incidents are rare, but certainly not unique.

Recently my friends Nigel and Alison were walking their dog near Brearley as a boat was passing through Lock 5. The water levels were very low and the boat grounded on the bottom. As my friends walked to Lock 6, a woman from the boat was winding a paddle there when suddenly her lock key slipped off the pinion. She fell forward into the water just in front the top lock gates and disappeared. The next few moments were ones of panic. The water sucked her through the sluice around the gate with great force and there was no sign of her. Suddenly she popped up in the lock, face down and unmoving. She must have passed right through the sluice. She appeared briefly in the water and then vanished again. Nigel ran across the bridge, unsure how to rescue her. Then she disappeared completely. He descended the lock ladder with the intention of reaching out to her or even – a last resort – going in after her. By this time a passing cyclist had joined him and dialled 999. It suddenly became clear she was no longer in the lock and had been sucked down again, then washed through the open paddle at the bottom gate. Nigel and the cyclist ran round the bottom lock gate and eventually managed to grab her and pull her onto the bank by the overflow. By now Alison had alerted the lady's husband who was attempting to refloat his grounded boat, while Nigel tried to revive the unconscious and injured woman. 'Do I try CPR or mouth to mouth resuscitation?' he asked himself. In the end he pressed on her back as she was face down and eventually heard some shallow breaths. Everyone was relieved when a person who was a nurse came to help and took over, followed quickly by a paramedic. The woman had been unconscious in the water for at least five minutes. Meanwhile the rescue services, including an ambulance and helicopter and the local search and rescue team, arrived and eventually, breathing again, she was taken to hospital by air and survived the ordeal. Alison and Nigel still have a sense of disbelief as they share the story today, as other bystanders thought the woman had just fallen in the water, when in fact she sustained serious injuries by travelling through the upper sluice and the open paddle in the lower gate.

Of Cyclists and Gongoozlers

The fine folk who inhabit Britain's canals can be neatly divided into five groups – boaters, walkers, anglers, cyclists, and gongoozlers. Each is worth a brief assessment.

1. Boaters

It's a perfect spring morning at Lock 17, near Todmorden, and an owner-driver named Brian is making his way gently to Manchester, before returning to his home in Doncaster via the Leeds & Liverpool. We get talking. I fit into four of these five categories and today I am both walking and gongoozling. Brian welcomes a hand with the lock gates and we chat about life as a boater. I am a hirer, but Brian took the plunge a few months earlier and invested in a craft that was proving too much of a responsibility for its ageing owners.

We chat about writing (he is the author of a successful children's book), the state of the locks on the Rochdale Canal, the delights of Calderdale towns and villages and the sense of freedom that owning a canal boat engenders.

'Ever thought about owning your own boat?' he enquired. Haven't we all? But I have moved around too much in my life, sometimes to places far from the nearest canal, so I am a serial renter. I am also a serial optimist, I revealed.

This remark prompts him to tell me the story of an inexperienced couple he met a few days earlier at Elland who were heading for Wakefield on the Calder & Hebble Navigation. It was a Sunday afternoon and they were struggling with an uncooperative lock mechanism.

'Imagine my surprise when they told me that their boat was due back miles away in Sowerby Bridge at 9 a.m. the following day,' said Brian. 'In the end the recalcitrant paddle was persuaded to open and we got them out of the lock. Then I suggested Wakefield was over-optimistic, if not impossible, as they had not yet reached Brighouse and Wakefield was 15 miles or so further on. So they reluctantly decided to return to Sowerby Bridge and I told them a turning point lay a mile ahead. Imagine my surprise when they simply reversed back into the lock, filled it with water, backed out and were last seen reversing along the canal in the direction of Sowerby.'

Contrast this with the fraught-looking woman I met steering through Hebden Bridge after a summit crossing that would test anyone's patience. 'We arrived at the west side of the summit to be told the locks were being closed for three days. Then there was no water so we ended up spending a total of five days near Lock 42. I mean, it's a pleasant spot but...'

At least they didn't have to hand their boat back first thing on Monday.

Then there is the Rochdale Nine – those first locks uphill from Manchester. Even seasoned expert, YouTube and TV star Robbie Cumming found the Rochdale Nine tough. 'It's grimy, it's gritty and it's not very pleasant smelling,' he warned his viewers after a six-hour solo journey. 'Yet' he added, 'it's one of my favourites.'

I love chatting to boaters, hearing their stories and, in the case of those who live aboard, wondering what life afloat would be like. But that's not going to happen for me now. I guess I missed the boat.

2. Walkers

I recently calculated that I had walked one particular 2-mile section of the Rochdale Canal eighty times. Boring? Of course not. Every walk was different. Many of them stay with me. A lady who had sadly lost her husband and now walks her dog on the canal for therapy. An angler whom I have often met walking, but never seen actually fishing. Walking groups who cluster together to enjoy a sociable stroll. People who find a bench and for some reason seem happy to just sit there – maybe I will join them one day. Strangers who love to help at locks – good news if they know what they are doing. Energetic youngsters, and not-so-youngsters, who bristle with Apple watches and Fitbits, wearing massive headphones and covering in an hour what would take me half a day.

People of all ages who wander hand-in-hand along the towpath taking in the sunshine, the scenery and each other. Lots of mums with pushchairs, headed to destinations unknown. It's a microcosm of modern life and for so many people the canal is an outlet for exercise, interest and sociability. It was worth restoring the canal for those people alone. Some of them recall walking on the towpath when it was a feeble trickle crying out for attention.

When the restorers of the Rochdale set their sights on what it could achieve, regeneration of the area was high up on their list. But that doesn't only mean breathing a new energy of economic life into the places through which it passes. It also means regenerating people – giving them a new outlet for recreation that is something beautiful and also ecologically stimulating. For Brian Holden, Richard Booth, Nigel Lord and so many others who made this happen, we should be eternally grateful. They really have changed lives.

3. Anglers

I confess it. I own a fishing rod. I haven't actually caught any fish with it, but I know some people who have. My son Edward bought it for me when we were cruising the Black Country Ring a couple of years ago and, armed with the necessary licences and permits, we dangled our hooks into the water every night. 'I'm fishing for perch,' I said knowledgeably. We caught nothing.

Things had changed since my youthful days as an angler. For a start, in the early 1960s I only fished where I could see a railway line, as steam

locomotives were way more important – I mean way, way more important – than fishing. But I seem to recall that we always caught *something* in the Grand Union Canal back in the 1960s. And now it should be much better because, most importantly, Edward had equipped us with modern bait, not maggots. This meant that we no more depended on a grotty tin of wormy squiggling things that seemed to be dunked in smelly sawdust and which squeezed out gooey white stuff when you put a hook through them. Maggots were history. No, we had modern, ecological bait. Technically interesting, clean, and no gooey white stuff. So we got that bit right, yet couldn't work out why we caught nothing.

Walking along the Rochdale Canal near Littleborough, I came across a friendly angler. He had two rods about 50 metres long that seemed to reach halfway to Leeds. He had a vast umbrella, a luxury folding seat that was probably made by G-Plan, a trawler-sized keep net and trunk-shaped boxes that contained every bit of hook, line and trinket that you would ever need. His kit stretched over 10 metres of canal towpath. When I came back an hour later, I asked him if he had caught anything. He showed me the smallest fish I had ever seen. I have seen bigger whitebait. Yet honestly, I was impressed. So I solicited some advice on our abject failure to clear the Black Country Ring of all its perch.

After telling him about our minuscule rods, tiny hooks and jazzy floats, all of which I blamed for our lack of success, he frowned and told me: 'You should have used maggots.'

4. Cyclists

Here we have a problem. To me, towpath cyclists fall into two distinct categories. The first are those who are practising for the Tour de France. They have no bells because it would add extra weight to their bike. They dress in clothes that no normal human being could get into, presumably applied by some shrink wrap machine when they get out of the shower. They are male, have a grey beard, sunglasses of the type worn by Australian cricketers and a bike that shouts 'technology'. I had a coffee with one at Jo's Kitchen café in Mytholmroyd after one of my canal walks and he told me his bike cost £15,000. I mean, *fifteen thousand*. You could buy a nicely matured Bentley Arnage for that money. The only warning you get of their approach is a sudden whoosh of air as they fly by intent on breaking the world cycling speed record (which, can you believe, stands at 183 mph). This is a very unnerving experience and makes a mockery of those CRT signs that suggest the canals welcome careful and considerate cyclists and that pedestrians have priority.

Then there is group two, and don't you love them? They tinkle their bells when twenty yards away, give a cheerful wave and comply with every rule that the CRT people advise. More, actually. On one occasion we were taking our hired canal boat along the Calder & Hebble Navigation in Yorkshire. Rashly, my wife had volunteered to do the locks, not aware that

the last time they had received a spot of lubrication was when William Jessop received an oil can for Christmas.

So she asked me for help and true to form I was useless. One paddle had been padlocked so it was out of use. The second paddle was so stiff that even Dwayne Johnson couldn't have moved it. But a cyclist pedalling along the canal spotted our plight and parked his bike. He came across to see if he could help. I don't know what cyclists eat these days, but it must include spinach, because after a few 'Wows' and 'Phews' he suddenly moved it. And then wound the paddle right up. I pleaded with him to stay around and he helped us to get out of the lock and then wound it down again before cheerily going on his way. Cyclists? I won't hear a word said against them.

5. Gongoozlers

A gongoozler is someone who 'idly spectates'. That seems to sum up half my life these days, but further investigation reveals it is a 100-year-old Lincolnshire term specifically referring to those who 'idly watched activity on a canal'. If you glance at a map you won't find too many canals in Lincolnshire, so presumably the gongoozlers crammed around the shortish Fossdyke Navigation and idly waited for hours until the next boat appeared.

But I like the idea of gongoozling. For a start it's a great word to set down in a word game. Or maybe casually use in conversation. 'I spent most of my day gongoozling and then went and enjoyed a latte at a cafe in Lincoln.' I have the sort of friends who would be impressed with that statement. Glance at some of my photographs in this book and you can tell when I was gongoozling. In fact I have a theory that, apart from those busy people who take sports pictures or chase celebrities, a large percentage of our photographers are also gongoozlers, waiting for the moment when the light is right and that chap in the hi-viz vest walks round the corner and out of the viewfinder. The promoters of the Rochdale Canal started working on their dream in 1766 and it was not finally opened until 1804. That's thirty-eight years, proving that this fine body of men were simply among the world's first gongoozlers.

And Finally...

It is Friday 12 August 2022 and the sun blazes down from a cloudless azure sky. As usual on a Friday I am walking along the Rochdale Canal between Luddendenfoot and Hebden Bridge. Of course, closures on this section are not unknown. But today is different. Chains wrapped around the paddle mechanisms at locks mean nothing afloat can move. The water is still and only the walkers and cyclists on the towpath disturb the peace. The CRT have closed the whole section from Sowerby Bridge to Littleborough due to a shortage of water. I feel an immediate sadness for boaters planning a summit crossing and especially for the team at Shire Cruisers who must rearrange hirers' plans at short notice. At least they can still sail east.

And this is the Rochdale Canal in a nutshell. Wonderful scenery, superb towpaths, fascinating waterside buildings and a worrying fragility due to the fact that only two third party water sources feed the canal and that simply isn't enough. If you are planning to tackle a voyage over the summit, you might be best to travel in winter or the 'shoulder' seasons of early spring and later autumn. That means it is very inconvenient if you are a holidaymaker or a boat owner wanting to see the Pennines at their sunniest. And even worse if, like Nigel and Susan Stevens, your business depends on open waterways. Yet this canal cannot fail to grab your heart thanks to its scenic beauty and overt industrial heritage. It remains in good hands.

In writing this book, I was given invaluable help by those who took a practical role in rebuilding the Rochdale Canal and who got to know every twist and turn, every beam and paddle. Thanks to Richard Booth, who put his vast collection of *two thousand* colour photos taken during the canal's restoration at my disposal; I honestly have enough fascinating pictures of his to make two more books! Thanks to Nigel Lord for his endless time, support and assistance. Susan and Nigel Stevens are still happily making holidays happen at their Shire Cruisers base in Sowerby Bridge. I am grateful to Alan Crowther, who took his camera and his son Andrew along the Manchester end of the canal in its grim pre-restoration days to record some of those views in colour for posterity. Also to Martin Macdonald for his excellent drone photos, to YouTubers David Johns and Robbie Cumming, to West Yorkshire Archive Service, and to Fran Read and Leon Edmonson of the Canal & River Trust. It's been a fascinating, happy, journey with you all.

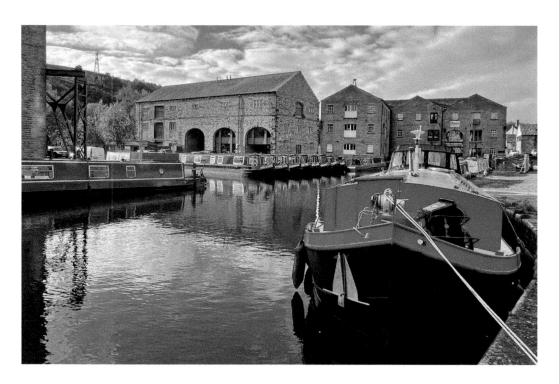

The Shire Cruisers fleet undergoes winter maintenance and a wide beam boat is moored at Sowerby Bridge Wharf in November 2021. (John Evans)

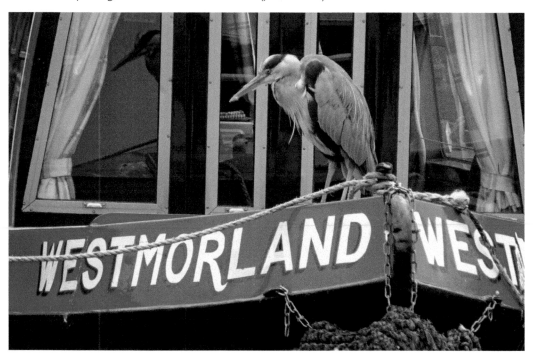

Guest on board. A heron does a spot of fishing from a boat at Sowerby Bridge in July 2020. (John Evans)

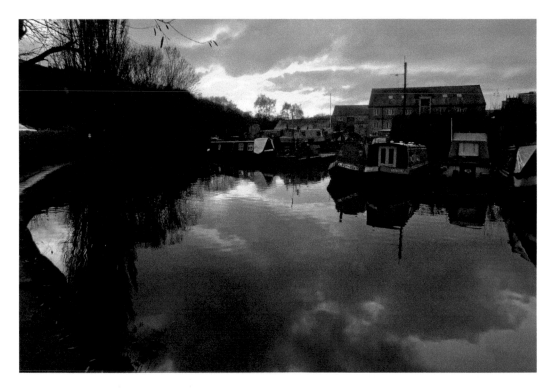

Sunset on the Rochdale Canal at the point where it meets the Calder & Hebble Navigation in Sowerby Bridge. (John Evans)

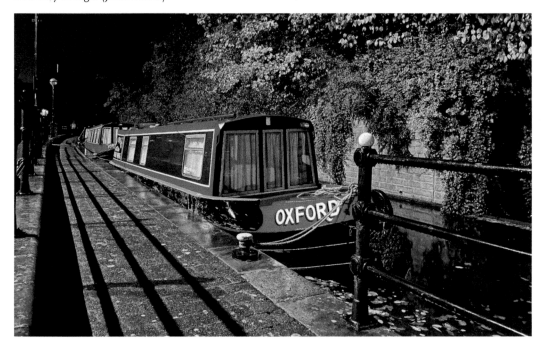

Overnight moorings at Sowerby Bridge for four boats awaiting an early passage through Tuel Lane Lock next morning in October 2021. (John Evans)

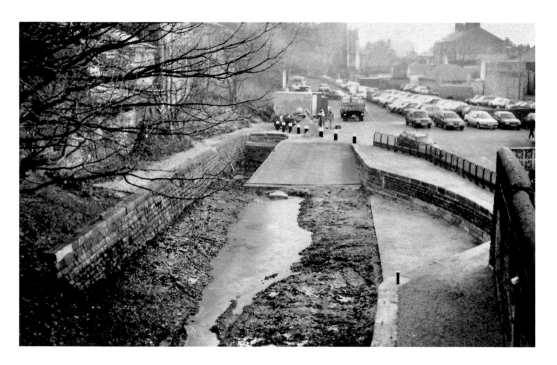

Sowerby Bridge in the late 1980s, looking to where Tuel Lane Lock is now. The canal beneath the road ahead consists of two 18-inch water pipes. A winding hole has been built to allow boats coming from the west to rotate and head back east. (Richard Booth)

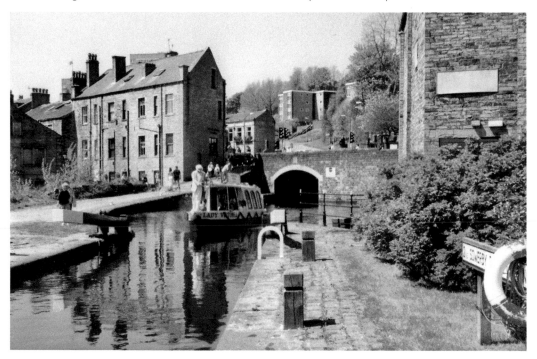

A millennium boat rally in 2000 brought many visiting craft to the canal. Here *Lady Victoria* leaves Tuel Lane Lock at Sowerby Bridge, which had been opened in 1996. (Richard Booth)

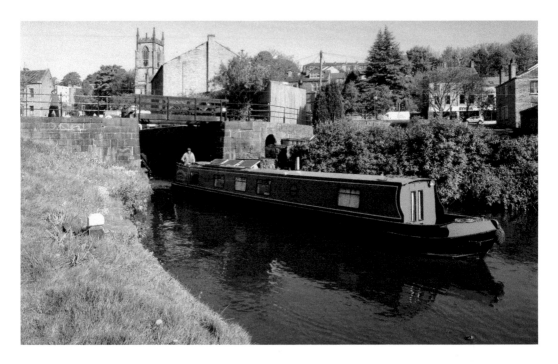

Tuel Lane Lock remains one of the 'must do' experiences on the canal system. The *Wilderness* heads out of the lock in May 2017. (John Evans)

From a boat in the bottom of Tuel Lane Lock in 2020, we watch the lock keeper who is keeping an eye on our progress. The manual locks are operated exclusively by a CRT team using a windlass that you can see to the left of the lock keeper. (Jane Evans)

We get the all-clear to leave the lock and burrow beneath the busy road junction in Sowerby Bridge using the new tunnel. (Jane Evans)

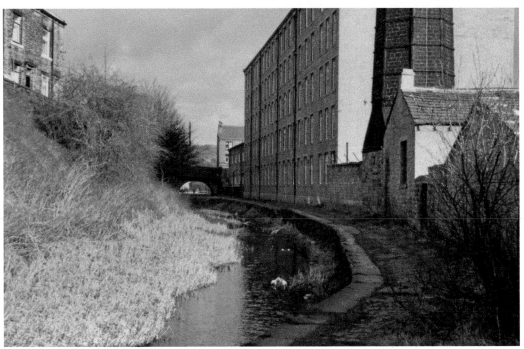

Sutcliffe's Mill at Sowerby Bridge before the canal was restored. Bridge 1 and Wainhouse Tower are ahead. (Richard Booth)

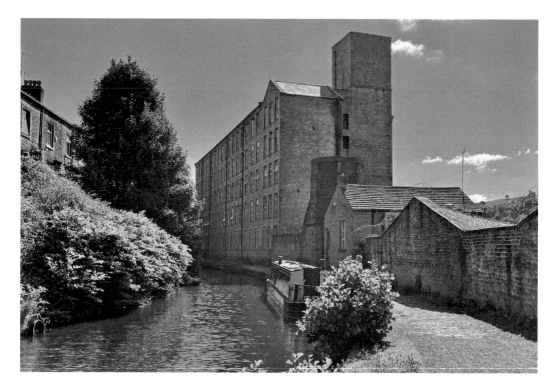

Forty years later a narrow boat is moored at the same location as the previous picture on a perfect summer day in 2022. The mill is still busy, but the octagonal chimney has sadly disappeared. (John Evans)

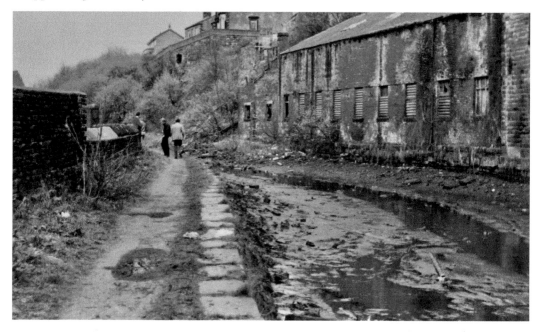

A scene near Sowerby Bridge in the 1980s. The building on the right has now been demolished. The derelict canal would hardly be recognisable by today's boaters and walkers. (Richard Booth)

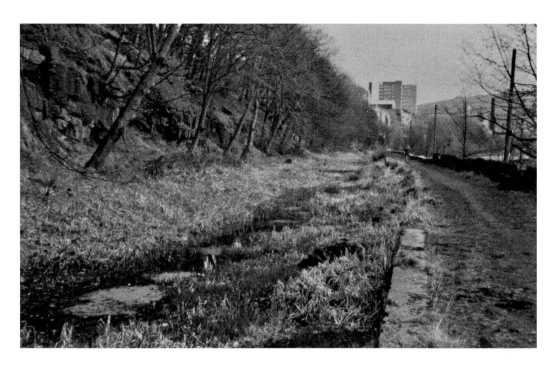

The canal leaves Sowerby Bridge on an embankment to the south and with a valley wall to the north. Even before reopening, this area was popular with walkers. (Richard Booth)

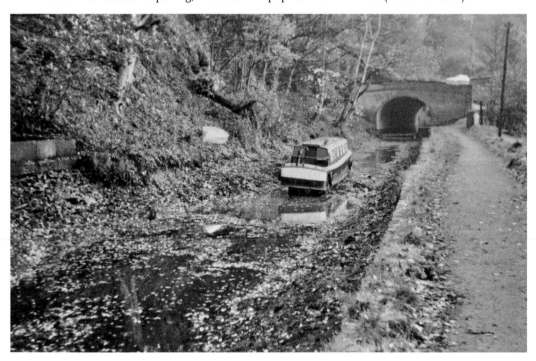

Hollins Mill Lane crosses the canal on a 40-yard tunnel (Bridge 2). Here on the west side a boat is stranded in the 1990s as, although navigable, the canal has been drained temporarily while work is carried out at Tuel Lane. (Richard Booth)

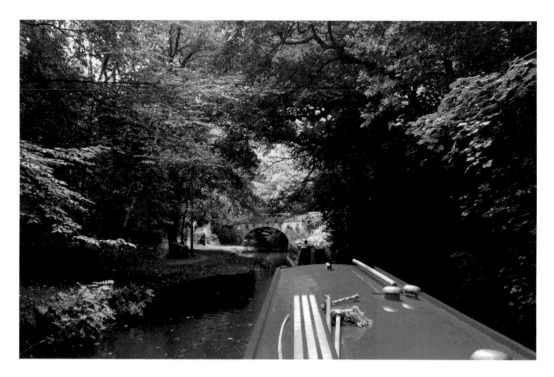

The stretch from Sowerby Bridge to Luddendenfoot is very attractive and partly concealed beneath a canopy of trees. Here we approach Longbottom Bridge (4) near Tenterfields. (John Evans)

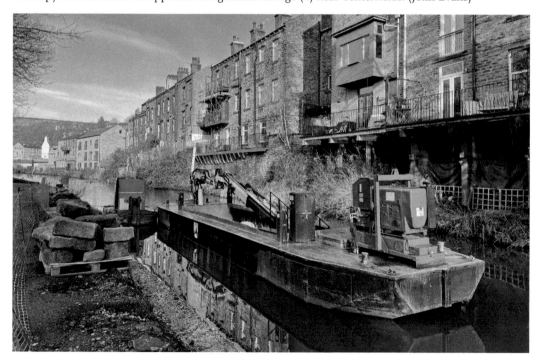

Towpath repairs in 2021 at Luddendenfoot, with a hired excavator boat in action and houses precariously lining the north bank. This craft was transported to the canal by lorry. (John Evans)

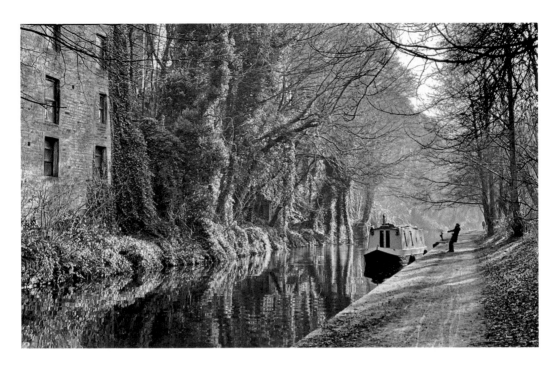

Solo crewing over the 92 locks to Manchester is not for the faint-hearted. On 18 January 2022 a boater moors at Luddendenfoot before setting off across the Pennines. (John Evans)

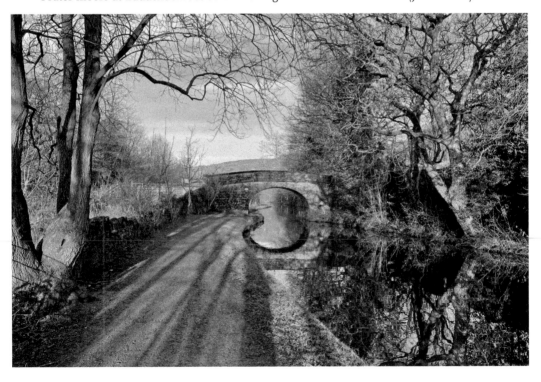

Long morning shadows mark the onset of autumn in 2021 at Bridge 7 near Luddendenfoot. (John Evans)

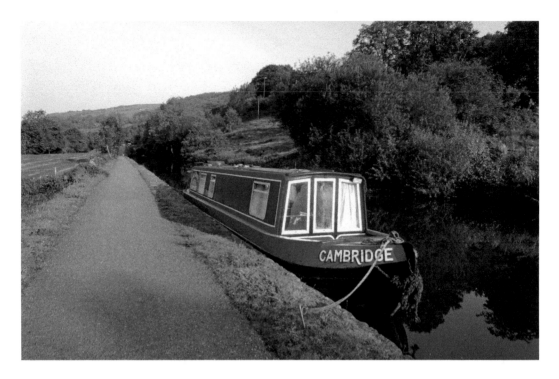

Serene moorings at Brearley near Edward Kilner Lock (5) as the sun sets after a perfect day. (John Evans)

Evening on the canal, with our boat at Edward Kilner Lock (5) near Brearley heading east. (John Evans)

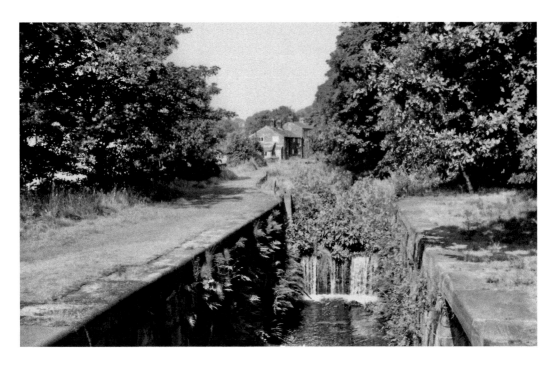

On the pretty section between Luddendenfoot and Mytholmroyd, nature took over while the canal was closed. At Lock 6 (Brearley Upper) water flows freely downhill, but the towpath is still passable. (Richard Booth)

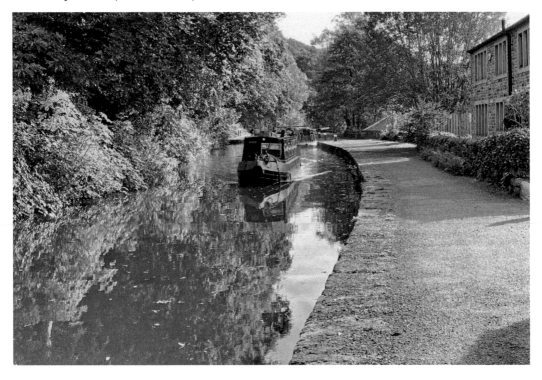

Brearley Upper Lock with a busy October scene in 2021. (John Evans)

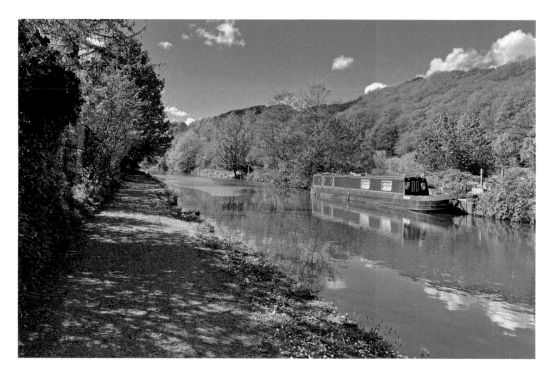

At Moderna Bridge (10) on the outskirts of Mytholmroyd, the canal looks peaceful on a perfect May morning. (John Evans)

A snowy day near Moderna Bridge at Mytholmroyd in January 2021. (John Evans)

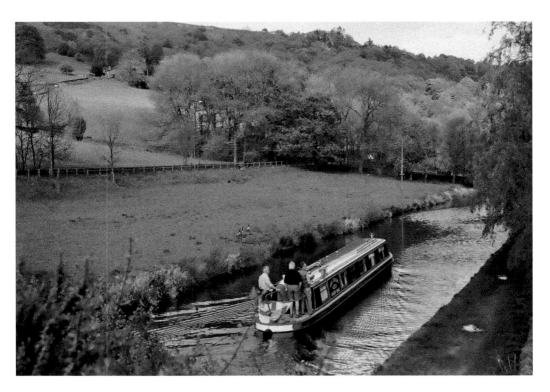

Cruising out of season in November 2018 near Moderna Bridge, Mytholmroyd. (John Evans)

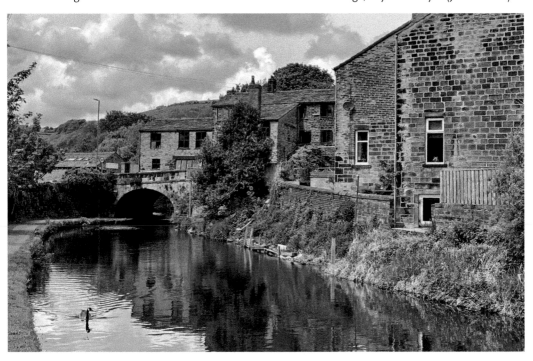

A cloudy morning at Mytholmroyd, where a house is built over Bridge 10, which carries the A646 trunk road across the canal. (John Evans)

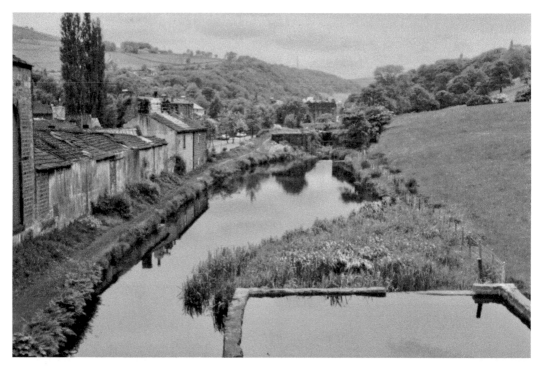

A view towards the Clog Mill from Mytholmroyd during the period of closure. (Richard Booth)

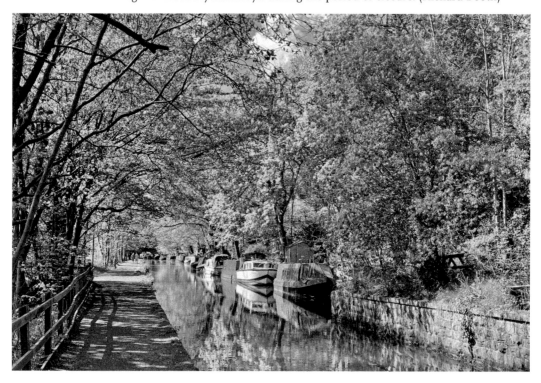

Spring brings wonderful colours to the canal. Here at Hebden Bridge, a row of house boats is moored in the sunshine. (John Evans)

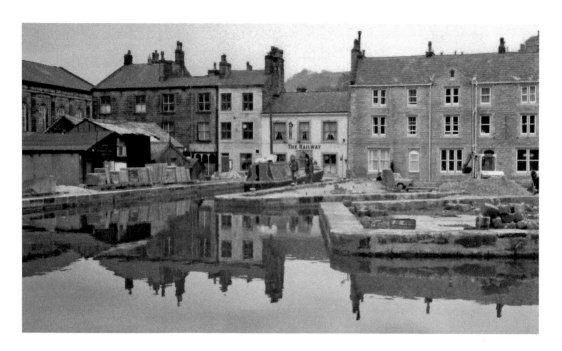

In the mid-1980s, the site of an old filling station at Hebden Bridge was used to create a new marina. On the left is the builders' merchant's yard of Oldfield Watson, who relocated to Mytholmroyd. (Richard Booth)

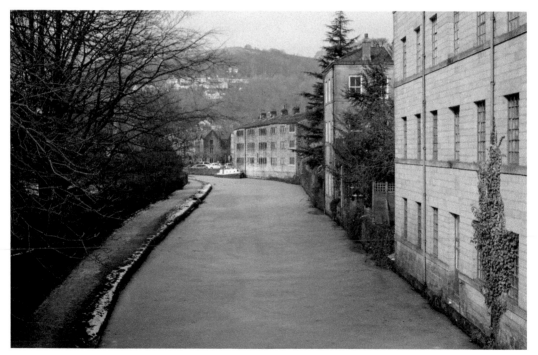

An eerily peaceful midday scene at Hebden Bridge in March 2018, with the Rochdale Canal completely frozen over and traces of snow on the icy towpath. You wonder how the old canal hauliers managed in such weather. (John Evans)

It's easy to miss the aqueduct in Hebden when on a boat, but from the air the River Calder can be seen passing beneath the canal amid much foliage. Blackpit Lock (9) is to the right. (Martin Macdonald)

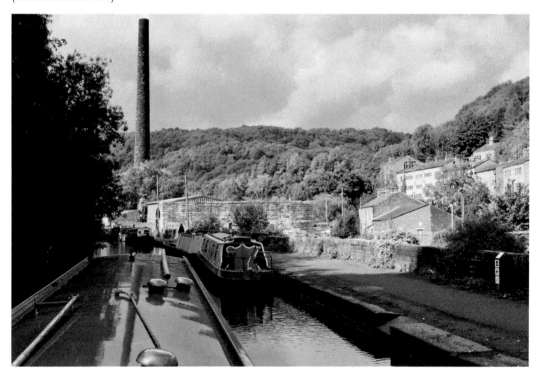

Just past Stubbing Wharf, west of Hebden Bridge, this tall chimney is a reminder of a once familiar sight along the whole of the Rochdale Canal. When this picture was taken in September 2020 most chimneys had long been demolished. (John Evans)

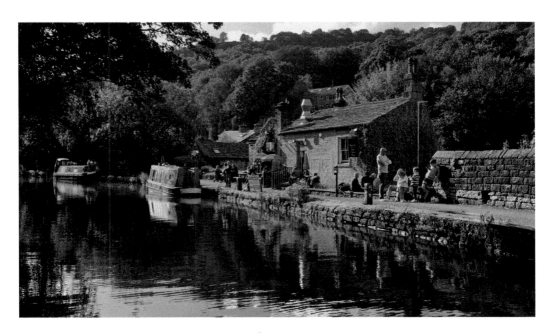

The Stubbing Wharf pub has always been a favourite stopping point for boaters and other canal users. Their trip boat can be seen moored outside the pub in 2020. (Jane Evans)

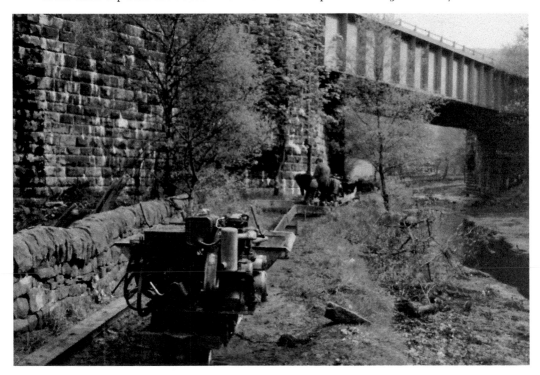

To remove the huge amount of silt near Whiteley Arches railway bridge (20), west of Hebden Bridge, a small railway was built utilising a locomotive and tracks acquired from a mine in Derbyshire. It wasn't completely successful – in the end letting the silt dry for a few months and removing it by lorry proved a better solution. (Richard Booth)

Rawden Mill Lock (12) was on the section reopened back in 1983 and makes a serene vista in winter snows during the mid-1980s. (Richard Booth)

In 1983, some of the first new lock gates are under construction at the Callis Mill workshops. These gates were built by a team with no prior knowledge of lock gate building, although a supply of old drawings for each gate proved invaluable. (Richard Booth)

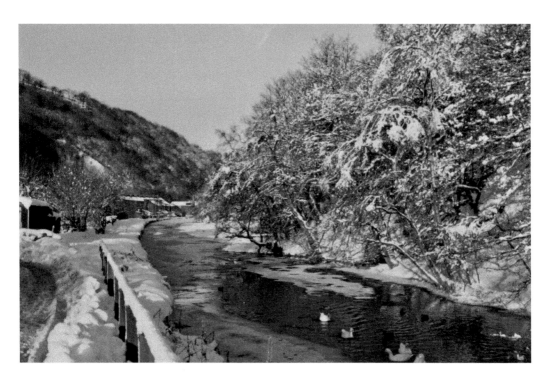

Near Holmcoat Lock (14), winter snows in the early 1980s disguise the fact that the Rochdale Canal here is derelict, although the lack of water is obvious. (Richard Booth)

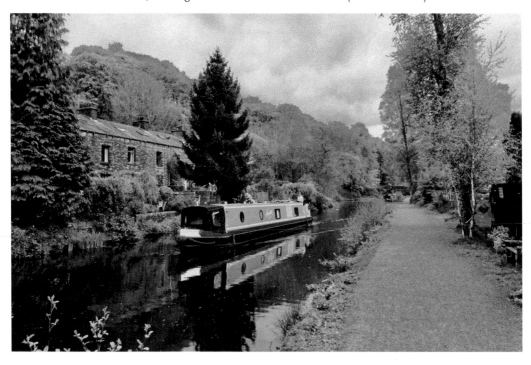

Early summer near Eastwood where an immaculate narrow boat at Stoodley Bridge is heading east in 2022. (John Evans)

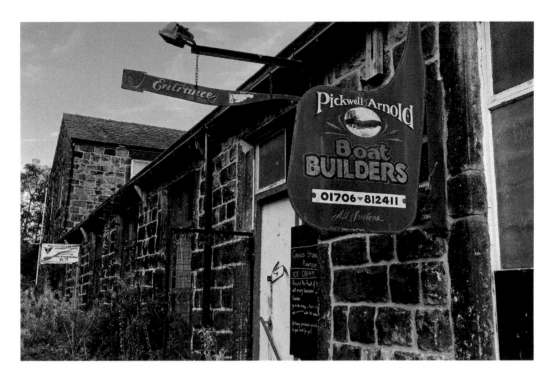

Pickwell & Arnold have this rather quaint rudder-shaped sign outside their premises at Lock 15, Shawplains. As boat builders based in an old canal-side mill they constructed some craft used by the rebuilding team. (John Evans)

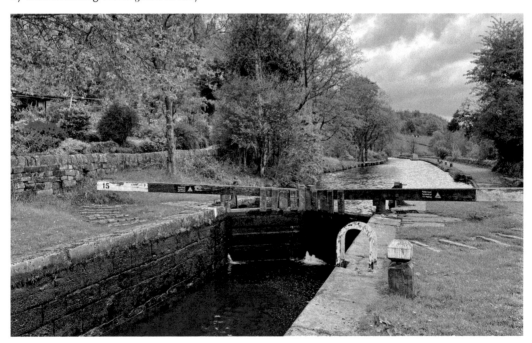

Shawplains Lock (15) is a pretty spot set between steep valley sides, seen here under a threatening spring sky. (John Evans)

Early morning near Lobb Mill Lock (16). Here the Calder Valley is narrower, with shallow sides as boaters prepare for the eastern assault on the summit. (John Evans)

A misty dawn moment east of Todmorden looking towards the summit. As the sun rose, the water surface was iridescent before the sky turned blue. (John Evans)

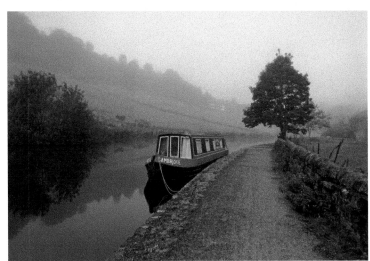

This view of the approach to Lobb Mill Lock (16) and the canoe centre in 2009 shows how the railway, canal and road struggle for space in the narrowing valley. (John Evans)

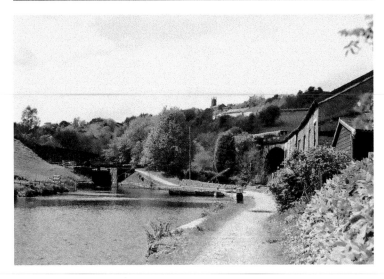

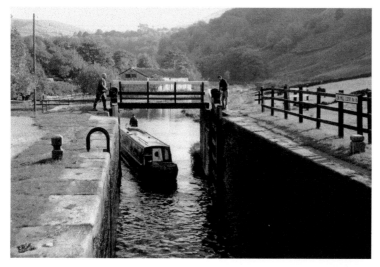

In the mid-1990s maintenance crews used a narrow boat to take them on missions to carry out minor repairs after the Todmorden–Hebden Bridge section had been reopened. One such trip enters Lobb Mill Lock (16) on the outskirts of Todmorden. (Richard Booth)

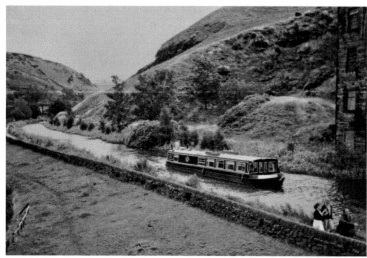

Looking east from Woodhouse Bridge (27) in the late 1980s, a restaurant boat passes the derelict Woodhouse Mill. Now allotments cover the left bank with trees opposite. (Richard Booth)

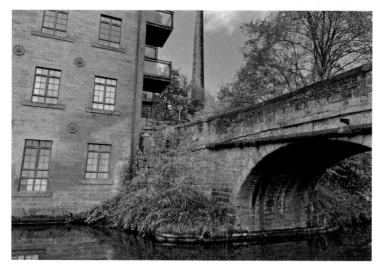

Woodhouse Bridge, with its landmark chimney and restored mill converted to apartments, one of the first conversions in the area. (John Evans)

Accidents are rare but they do happen. Here the crew of *Rochdale Princess* has left the boat's stern on the cill as the water is drained from Old Royd Lock (17) at Todmorden, with dire consequences. (Richard Booth)

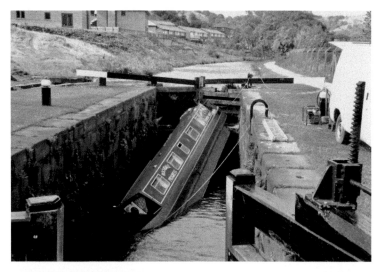

Baltimore Bridge (29) is in Todmorden, and this image shows how the canal switches quickly between the urban and the rural in a few hundred metres. (Jane Evans)

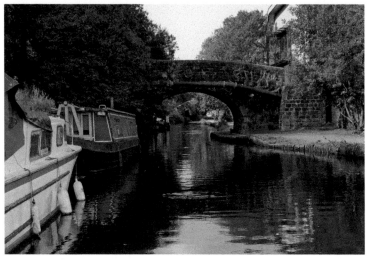

A view near Shop Lock (18) in Todmorden in the mid-1980s after reopening, with Mario's Garage on the left and Stoodley Pike on the horizon. (Richard Booth)

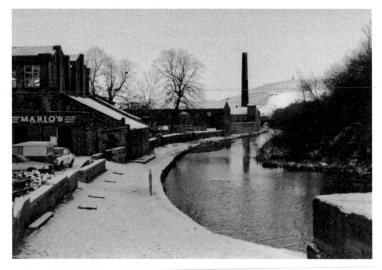

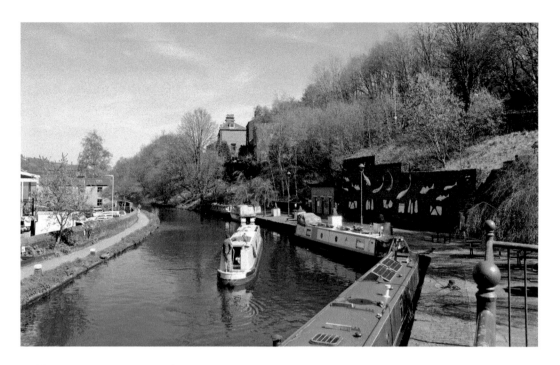

Fielden Wharf at Todmorden has excellent facilities for boaters and decorative fish on the walls. (John Evans)

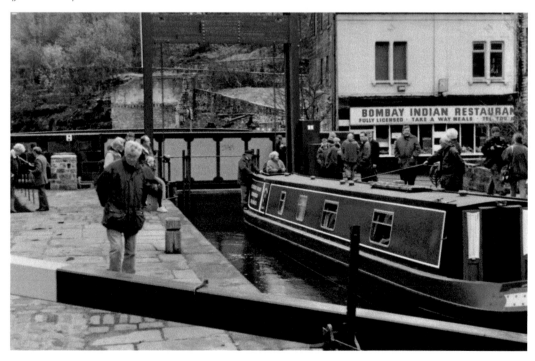

In 1995 the new Library Lock was opened at Todmorden with a guillotine because there was no room for balance beams. The restaurant building has since been demolished making the area seem much more open today. This is the scene on opening day. (Richard Booth)

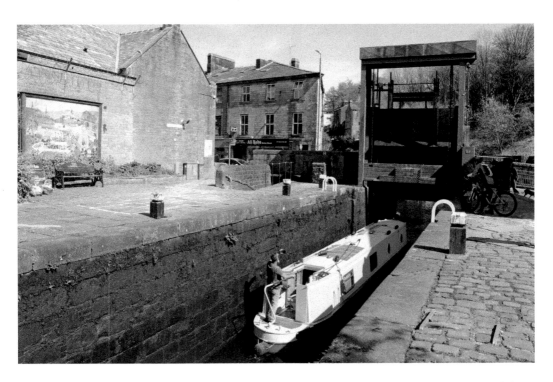

The guillotine lock at Todmorden still attracts admirers. Here, in 2022, the massive gate lifts as a cruiser moves forward. (John Evans)

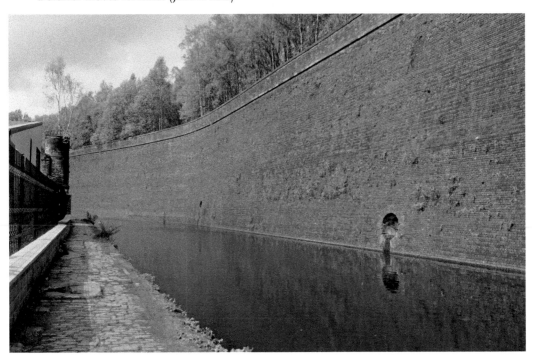

The so-called 'Great Wall of Tod' at Todmorden. Great it is, being constructed from about 4 million bricks. (John Evans)

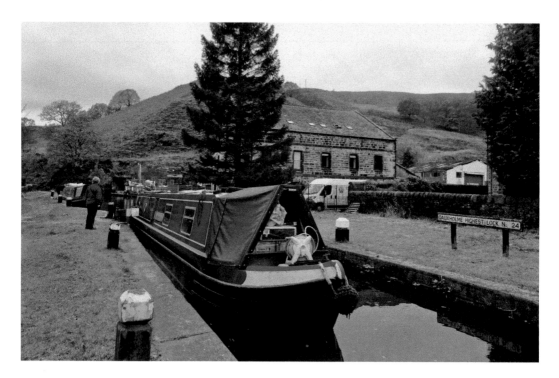

Winter passage through Gauxholme Highest Lock (24). The undulating scenery here is typical of this section. The building behind the lock has a dock. (John Evans)

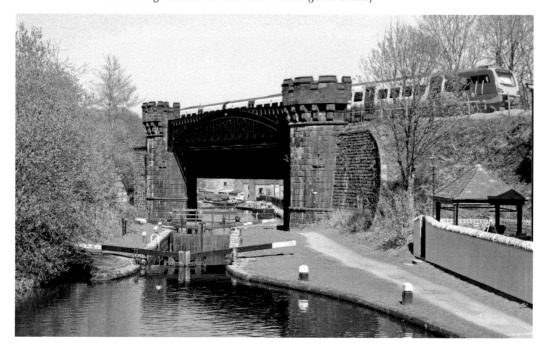

A train for Manchester crosses the canal south of Todmorden on the magnificent cast iron bridge at Gauxholme (30B), designed by George Stephenson. Now a listed structure, its handsome towers complement the elegant span to create the finest bridge on the canal. (John Evans)

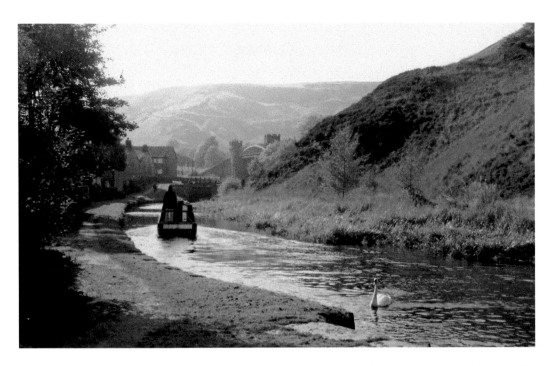

A pleasant scene near Gauxholme after the opening of the Todmorden–Hebden Bridge section, with a maintenance boat seen heading west towards the familiar railway viaduct. (Richard Booth)

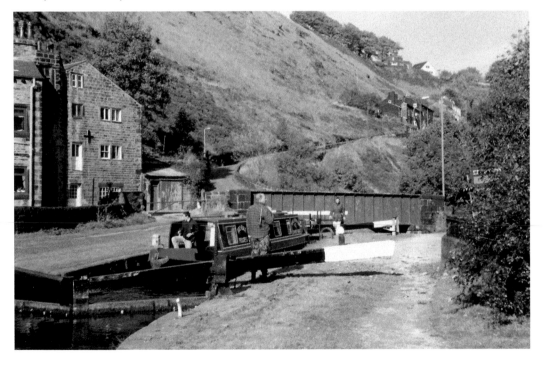

Back in the early 1990s the *Rochdale Princess* is seen at Gauxholme Highest Lock (24) with the Bacup Road Bridge in the background. (Richard Booth)

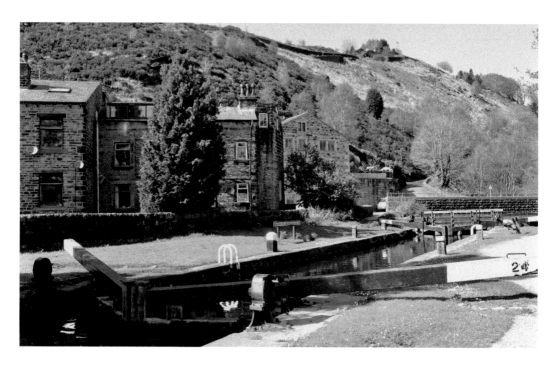

With hillsides covered in heather and charming stone houses, the area around Gauxholme is deceptively rural, squeezed between two valley sides as it climbs to Walsden. This picture mirrors the previous scene, but was taken thirty years later. (John Evans)

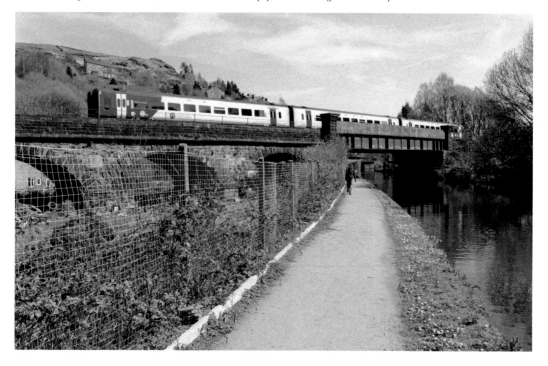

The Manchester to Leeds railway crosses the canal twice in a few hundred yards, but the second bridge (31A) is much less spectacular. Note the houses high on the hillside. (John Evans)

In 1995 this restored section of the canal at Walsden is seen following heavy snow, which caused flooding. Travis Mill Lock (28) is in the foreground with Nip Square Lock further on. (Richard Booth)

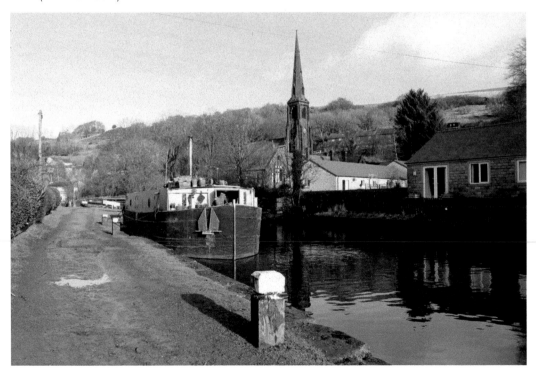

A wide beam boat moored at Walsden near Nip Square Lock (29) watched over by the elegant spire of St Peter's Church. (John Evans)

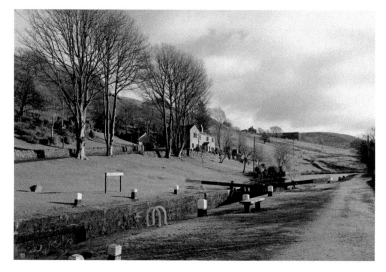

Lightbank Lock (31) is one of the most attractive on the whole canal, situated on the southern outskirts of Walsden. (John Evans)

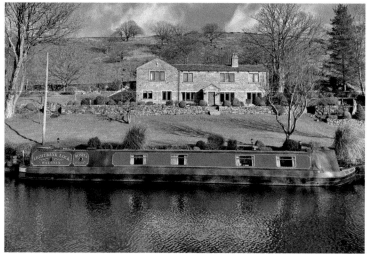

A sparkling January day near Lightbank Lock where a brightly coloured narrow boat sits below nature's greens, golds and blues. (John Evans)

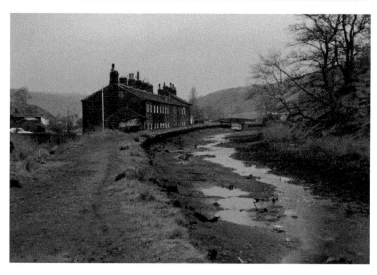

A view of Bottomley Lock at Walsden (33) in the 1980s when the team were assessing the scale of the work. (Richard Booth)

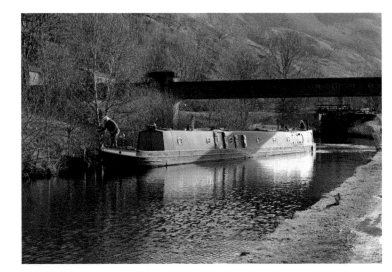

Warland Pipe Bridge and Lock 35 (Warland Upper), with a mooring drama under way. (John Evans)

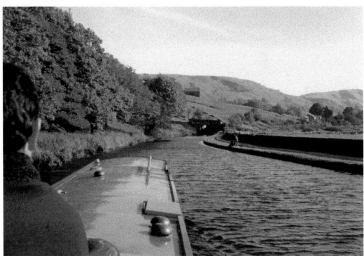

After the canal was reopened some journeys to deal with maintenance issues kept the restoration team busy. Nigel Lord is on one such trip on a lovely autumn day in the mid-1990s between Walsden and the summit. (Richard Booth)

Just north of the summit, this boundary post marks the border between Yorkshire and Lancashire. (Jane Evans)

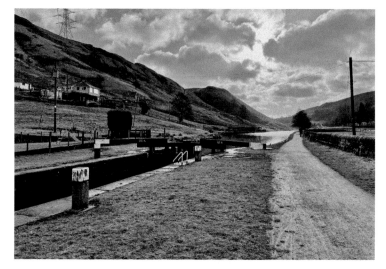

Longlees Lock (36) marks the eastern summit, where the scene is wild moorland and the canal pound is wide. This January view looks remote, yet the sound of traffic and Summit village were only a short distance away. (John Evans)

Water is often short at the summit, so here in the 1980s before restoration the canal is very shallow. Summit village is on the left. The area on the left is now playing fields. (Richard Booth)

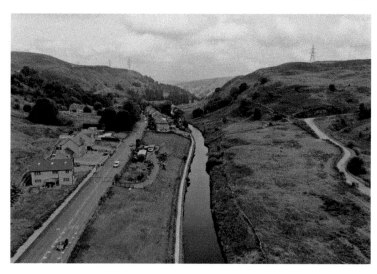

Summit village in 2022 with new housing on the left and the canal crossing level ground before the descent to Sowerby Bridge. (Martin Macdonald)

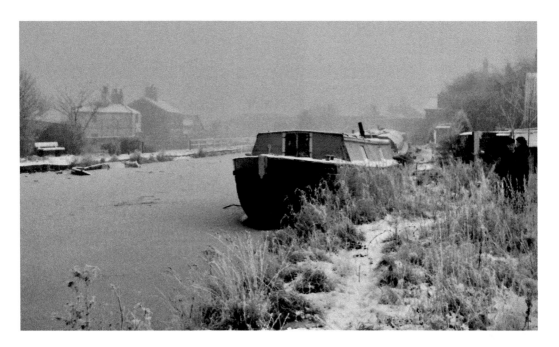

Although Richard Booth took photos mainly as a record of the Calderdale team's progress, he could not resist the occasional scenic picture. Here the frozen canal plays host to moored wide beam boats in the mist near the summit before this section was fully restored. (Richard Booth)

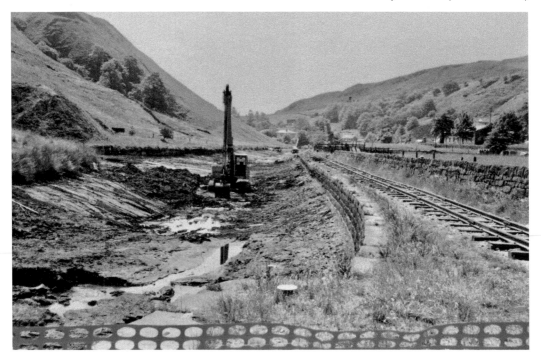

Dredging work carried out at the summit cost a lot of money as the water was contaminated with acids, which had to be treated and then removed to sealed sites. The temporary railway was used to remove silt. (Richard Booth)

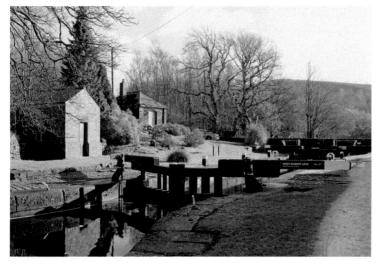

The first lock beyond the summit is West Summit Lock (37) and boaters heading for Manchester may feel they are halfway along their journey; in fact they have fifty-two more locks to tackle. (John Evans)

Peaceful winter moorings west of the summit between locks 39 and 40. (John Evans)

Near Lock 41 (first Below Punchbowl) just west of the summit, a working boat carries new lock beams ready for installation. The powered craft called *William Jessop* was built from scratch for use by the canal restorers. (Richard Booth)

Rock Nook Mill at Littleborough occupies a dramatic location right next to Lock 42 (2nd Below Punchbowl). Back in 1986 it was still a working factory for Fothergill and Harvey alongside the long-abandoned canal. The remains of Lock 42, with its gates missing, can be seen at the far end of the mill. (Miocene)

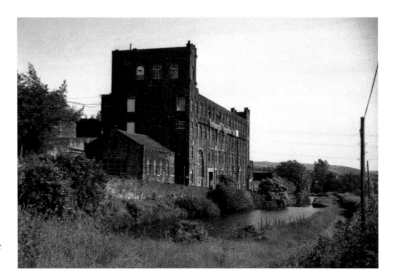

The sad shell of Rock Nook Mill, with Lock 42 alongside and the railway sweeping south towards Rochdale in June 2022. (Martin Macdonald)

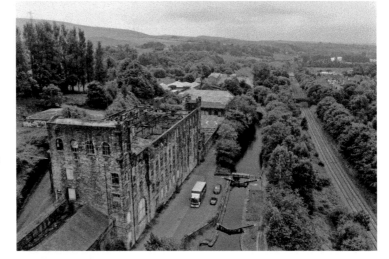

These days Rock Nook Mill is a gaunt but impressive fire-damaged ruin, but the canal has enjoyed better fortunes. Lock 42 is now back in use. (John Evans)

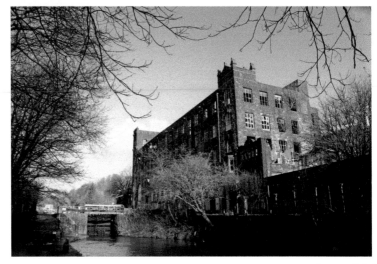

Lock 43 south of Summit is the site of this fascinating picture taken before restoration started. The canal is a trickle, a daunting prospect for restorers. (Richard Booth)

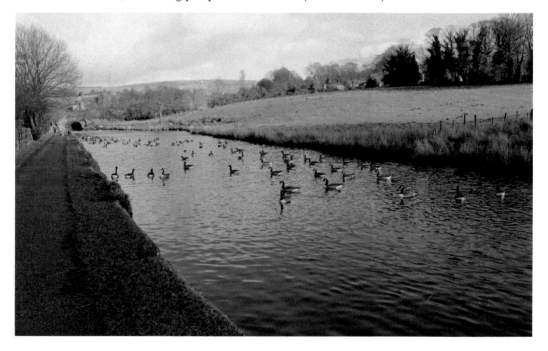

Shoals of Canada geese are a familiar site on our canals and these near Bent House Bridge (46) were keeping clear of dog walkers. Canada geese have been in the UK for more than one hundred years, but their numbers are increasing rapidly. (John Evans)

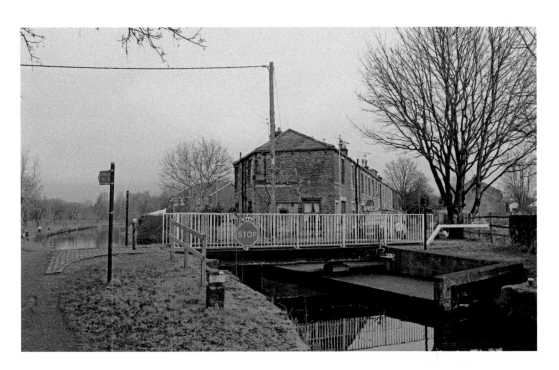

Bridge 54A is Little Clegg Swing Bridge, just to the west of Smithy Bridge. The old house by the bridge was once a candlemaker's shop, and an isolation hospital stood on the hill nearby. (John Evans)

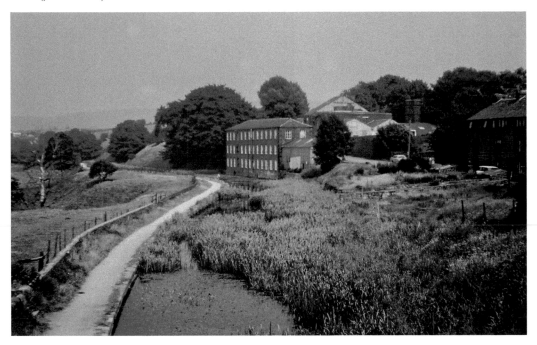

The overgrown and disused Rochdale Canal at Clegg Hall, near Smithy Bridge, is seen here in July 1989. Clegg Hall Mill was destroyed by fire in 2005 after an arson attack, but has since been rebuilt as apartments. (Andrew K. Crowther)

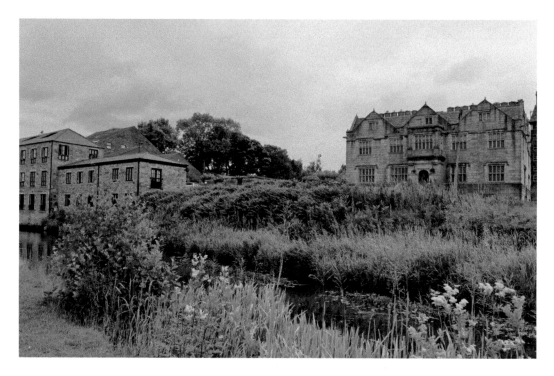

More than thirty years after the last picture, Clegg Hall Mill has been rebuilt and so has the adjacent beautiful old hall. (John Evans)

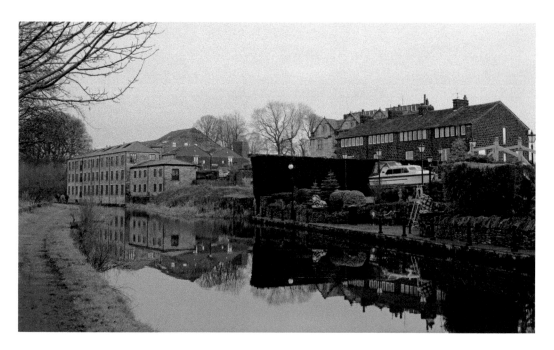

Clegg Hall and its mill are a graceful addition to the waterway at Smithy Bridge. But how is that boat going to be launched? (John Evans)

This bridge carries Manchester trams over the canal near Rochdale and was once part of the Oldham to Manchester railway. It reopened as a tramway in 2012 between bridges 58 and 58A. (John Evans)

Moss Locks in Rochdale in the mid-1990s, bereft of water and work just starting on restoration. (Richard Booth)

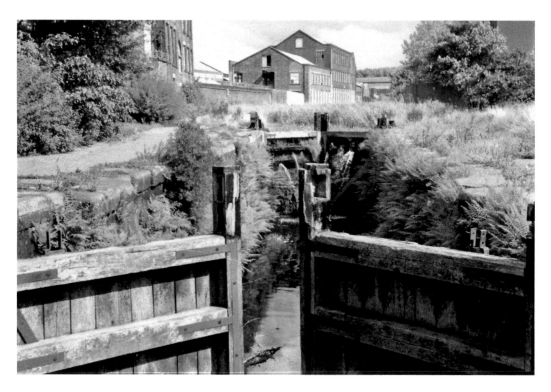

Another view in Rochdale of Moss Locks before restoration. Moss Mill can be glimpsed on the right. (Richard Booth)

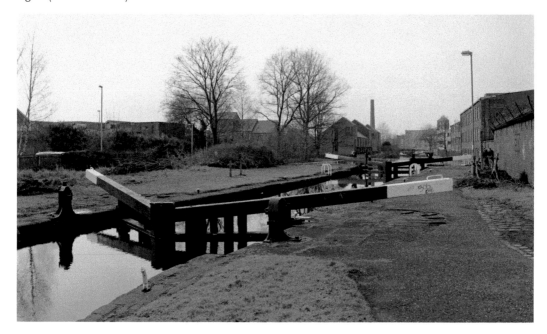

Lock 49, Moss Upper, in winter with a CRT volunteer working party clearing the towpath on the right. The building behind them can also be seen in the view taken by Richard Booth forty years ago. (John Evans)

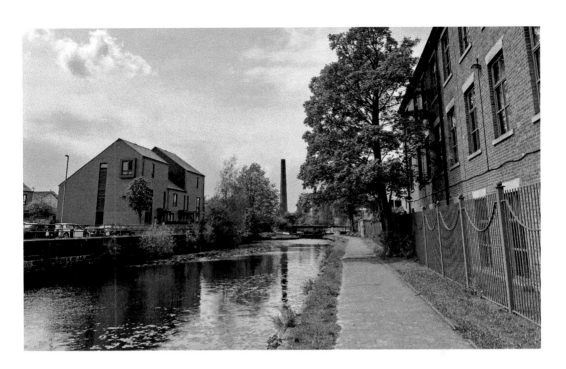

Rochdale transformed in springtime, with Lock 50 ahead and everywhere looking immaculate after amazing work by volunteers. However, even today some areas of Rochdale's towpaths can prove challenging. (John Evans)

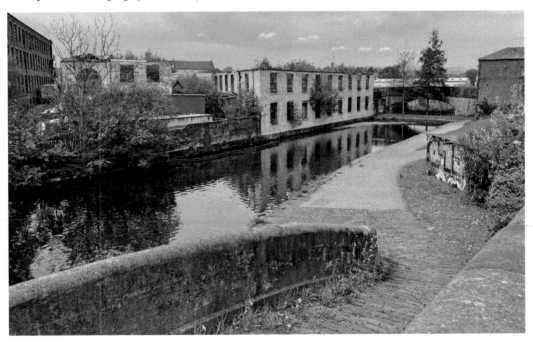

The old Rochdale Arm, which once ran for half a mile to the town centre, but today is just a short stump. The canal ran beneath the arched bridge in the middle distance, viewed from a bridge over the main canal. (John Evans)

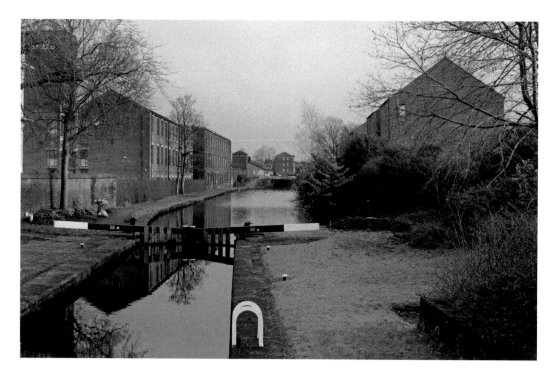

Lock 49 looking towards Lock 50 in Rochdale (Moss Locks) with Oldham Road bridge in the distance and a CRT volunteer clearing undergrowth. (John Evans)

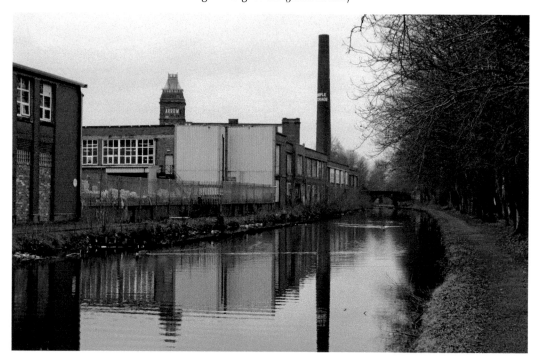

One of the last working mills in Rochdale, Arrow Mill, like most others, depended on the canal for transport and water supply for its steam engines. Now it is used for storage. (John Evans)

At Edinburgh Way in Rochdale the canal enters a tunnel (62B) to pass beneath a large road junction. The towpath diverts over a roundabout and behind a BMW car dealer before rejoining the waterway at this point. (John Evans)

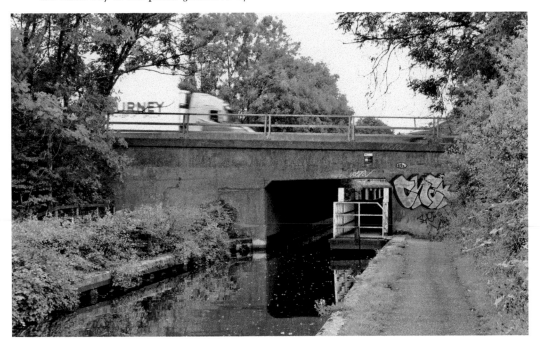

The M62 was built across the canal at Castleton, cutting it in two. The solution to reconnecting it was to expand a culvert bridge (now 65C) with a floating towpath that can be removed on the odd occasion when a wide beam craft needs passage. Graffiti rules, sadly. (John Evans)

The M62 work involved a new lock and rerouting the canal. The old line of the canal curving right can be seen on this view looking towards Manchester, now just a blocked spur. (John Evans)

Another view of the blocked line of the old canal (left) with the new formation running (right) into a new Lock 53 and under the motorway. (John Evans)

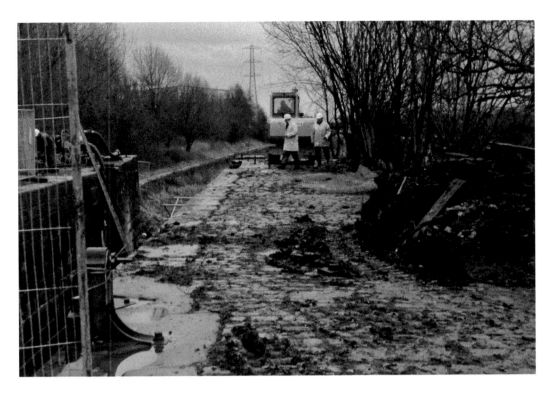

Lock rebuilding work under way at Slattocks. It's a wet day on the outskirts of Manchester, but work goes on. This is another textile village, in what was once a farming area, but is now a distribution centre. (Richard Booth)

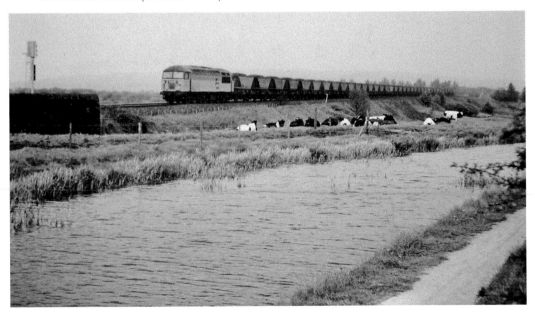

In May 1992, although parts of the canal had been reopened, there was much work to do east of the summit. Here a train of Yorkshire coal, probably bound for Fiddlers Ferry power station, runs alongside the overgrown canal near Slattocks. (Alan K. Crowther)

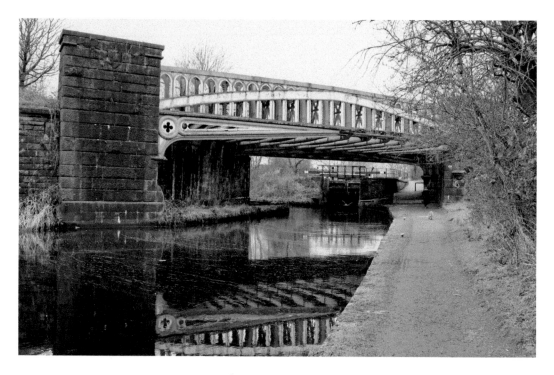

Scowcroft Lock (61) and another superb cast iron skewed bridge accommodating the Leeds to Manchester railway marks the entry to Chadderton. (John Evans)

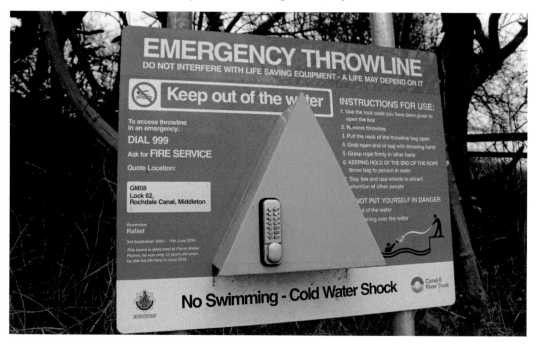

Beside Coney Green Lock (62), at Middleton there is a grim reminder of the dangers of canal locks. An emergency rescue line has been sited at the lock in memory of a thirteen-year-old boy who died here in 2016. (John Evans)

From high above we can see how the River Irk wanders through the fields near Mills Hill, while the canal is on a wide loop to avoid rising ground. It crosses the river on a sturdy aqueduct. (Martin Macdonald)

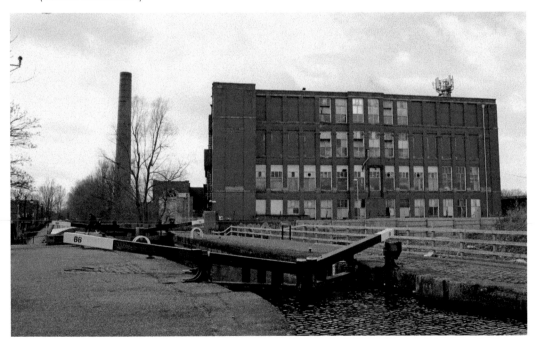

Much of Marlborough Mill by Lock 66, Tannersfield Highest, survived a demolition threat; near here a bridge carrying Poplar Road had been lowered so it skimmed the canal's surface, but it was replaced by a rugged new red brick structure. (John Evans)

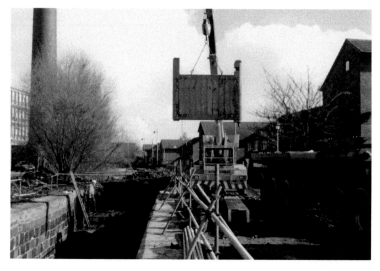

Suspended high above the canal is another lock gate built by the team at Callis Mill workshops in Hebden Bridge. This is Lock 67, Tannersfield Middle, at Failsworth with Marlborough Mill on the left. (Richard Booth)

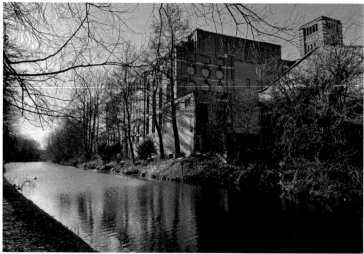

Built in 1904, Malta Mill at Chadderton (near Bridge 74) was one of many huge cotton mills built in the early years of the century. It closed in 1963 and happily has survived to find a new life as warehousing and industrial units. (John Evans)

Grimshaw Lane Lift Bridge (75A) is mounted on hydraulic rams, the only bridge of its kind on the Rochdale Canal. It replaced a very low bridge installed when the canal was closed, but the original bridge here was also a lifting device. (John Evans)

The canal passes through a new tunnel beneath the M60 motorway. Pedestrians, meanwhile, have to detour across this lengthy new footbridge (76A) over the road, one of the biggest obstacles when the canal was rebuilt. (John Evans)

In the early 1990s, work is underway at the Laneside flight in Failsworth installing new gates on the rebuilt lock. Beyond the lock the canal is impassable. (Richard Booth)

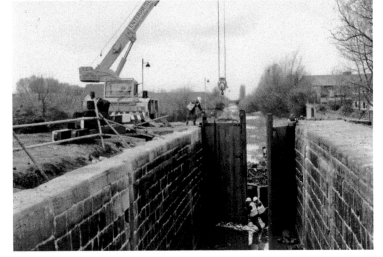

Regent Mill is another surviving cotton mill alongside the canal at Failsworth. Now occupied by Russell Hobbs and Remington, it sits near Bridge 79. A tall chimney and boiler house were demolished in 1964. (John Evans)

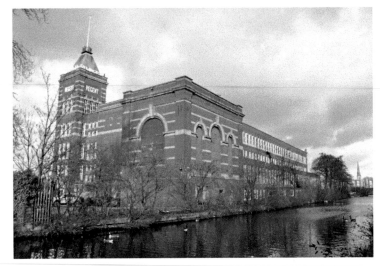

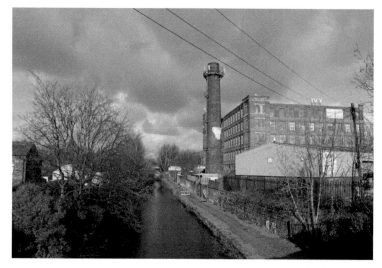

Ivy Mill at Failsworth has a proud history of making cotton and later aircraft parts. It is now a swish business centre, standing near Lock 65. (John Evans)

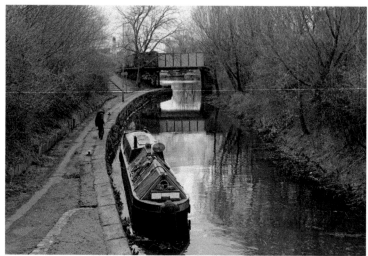

The area near the railway bridge by Slaters Lower Lock (76) at Newton Heath offers a brief tree-lined respite from the mills and new development. Part of the fascination of the canal is its ever-changing surroundings. (John Evans)

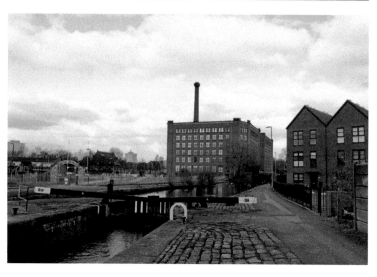

One of the most striking buildings on the descent to Manchester is Victoria Mill at Miles Platting. This area once boasted endless terraced housing for mill workers. (John Evans)

A charming vintage picture at what is now Lock 80 at Miles Platting, but a close inspection reveals that low concrete bridges have been built across the filled in canal. Nineteen of these had to be removed. The filled-in canal is covered by a couple of inches of water. (Richard Booth)

Just off the canal at Ancoats is New Islington Marina, which has excellent moorings alongside both new and old buildings, for leisure or living. (John Evans)

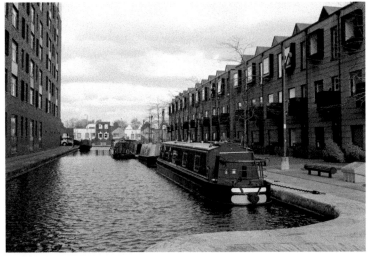

One of the locks tackled by the Calderdale team was 82 next to Kitty Footbridge at Ancoats. Here we see it in the early 1990s just before work started. It gives a good idea of the scale of reconstruction needed to rebuild the canal. (Richard Booth)

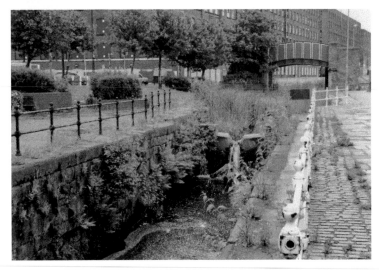

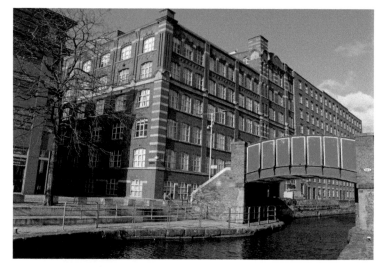

Kitty Footbridge in 2022 with Royal Mill now converted to apartments, offices and shops. It was renamed from New Old Mill following a visit by the King and Queen in 1942. (John Evans)

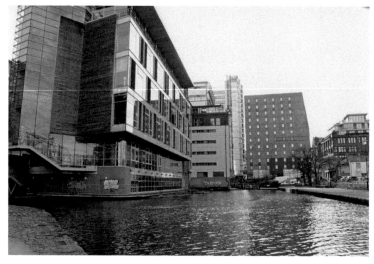

The Ashton Canal joins the Rochdale at Ducie Street Junction, heading off left. Ahead is the start of the Rochdale Nine, with Lock 84. (John Evans)

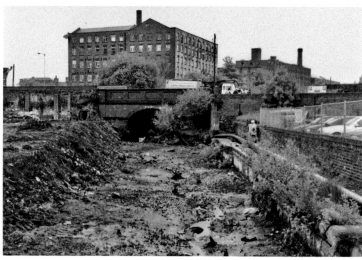

Beyond repair? Actually, no, but this 1990s scene in Ancoats shows a pretty desperate situation. (Richard Booth)

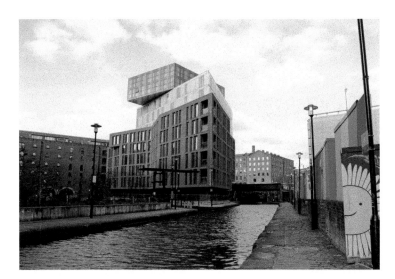

The canal in 2022 with the same mill in the background and a new, private marina on the left. (John Evans)

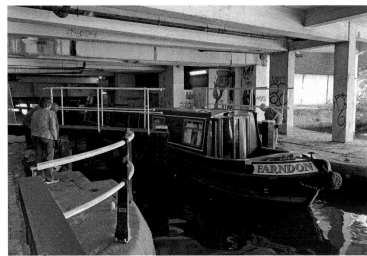

Farndon emerges unscathed from the grim surroundings of Lock 85 under Manchester city centre, helped by a CRT volunteer. (John Evans)

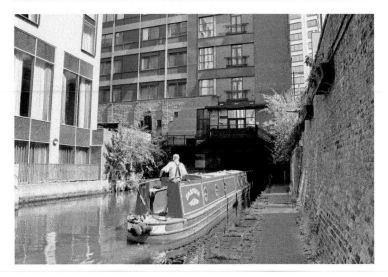

The entry to Lock 85 with Barney Bardsley and crew nearing the end of the Rochdale Nine. (John Evans)

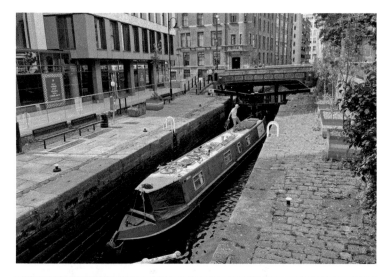

Lock 87 on a summer morning, with a few gongoozlers watching progress. (John Evans)

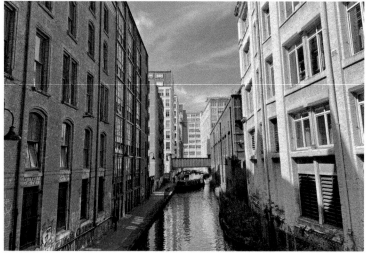

Tall buildings surround the canal as we climb the Rochdale Nine, the old blending harmoniously with new developments. (John Evans)

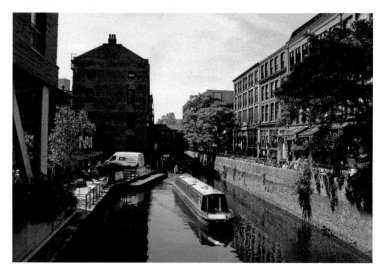

Morning in the Gay Village, with coffee and sunshine making an ideal start to a July weekend. (John Evans)

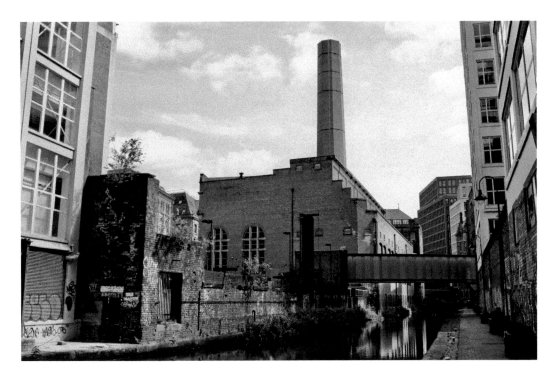

The sombre approach to Piccadilly tunnel with the massive chimney of Bloom Street Power Station looming over the canal near Oxford Road Lock (88). (John Evans)

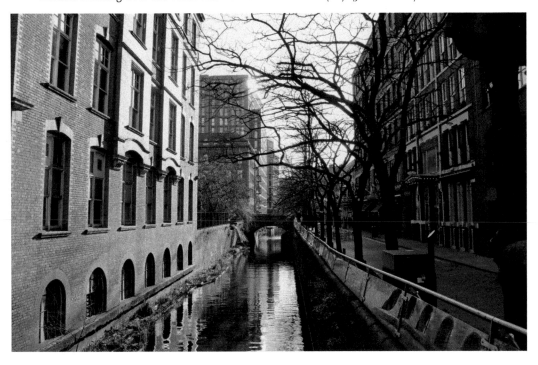

Minshull Street Bridge (94) in central Manchester. The towpath disappears and you have to walk along the road on the right. (John Evans)

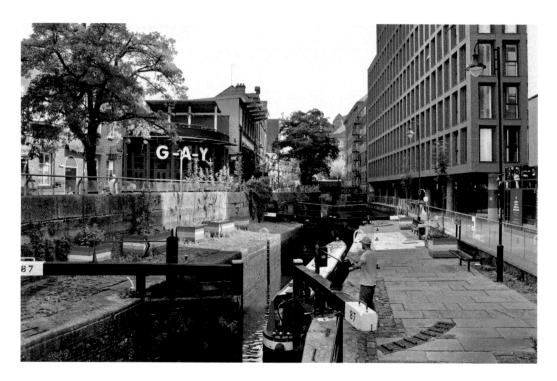

Princess Street Lock (87) on a sunny March afternoon. The area around here livens up in the evenings. Boaters are halfway through the Rochdale Nine. (John Evans)

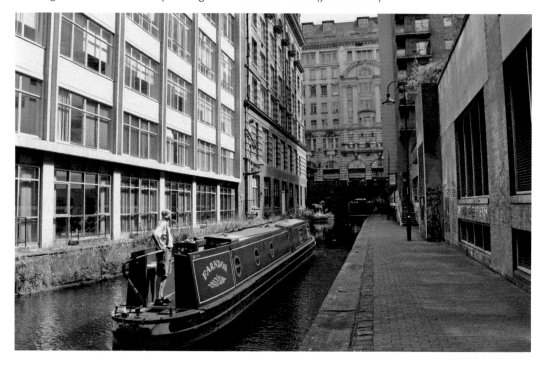

After a gloomy tunnel beneath Oxford Street, *Farndon* will reach Lock 88 on its way out of Manchester. (John Evans)

Leaving Tibb Lock (89) in central Manchester, which is on the south side of Havelock Mills. It is Grade II listed. (John Evans)

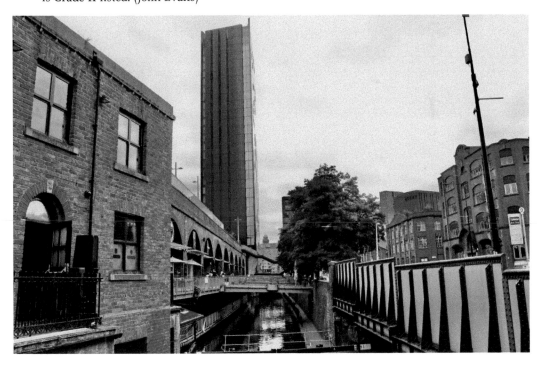

The canal now clings to the tram and railway viaducts, with Deansgate Tunnel Lock (91) below us. (John Evans)

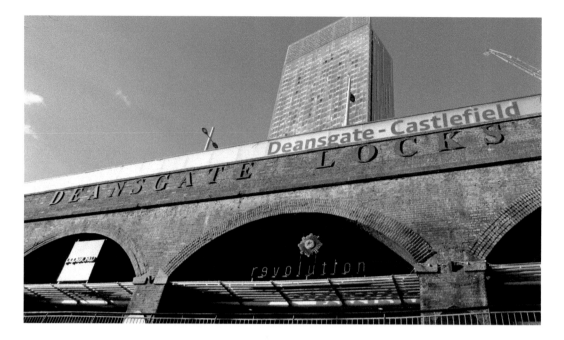

The final stretch of the Rochdale Canal into Castlefield Street Basin sees a long railway viaduct leading to Oxford Road and Piccadilly stations above the canal. Lock 90 is also sited here. The railway arches now house bars and restaurants. (John Evans)

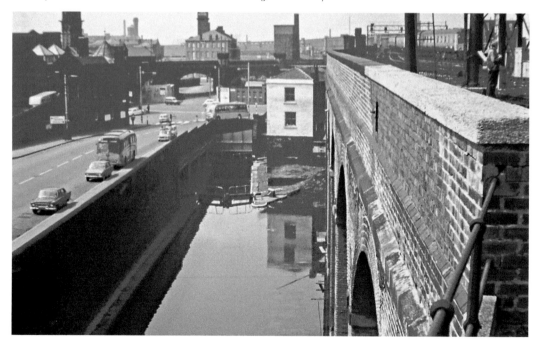

From the turntable bay at Manchester Central station, we look down onto the moribund Rochdale Canal, as it runs parallel with Whitworth Street with its two period motor coaches. Manchester Central closed two days after this picture was taken on 3 May 1969. Today Metrolink trams have replaced the approaching train. (Alan K. Crowther)

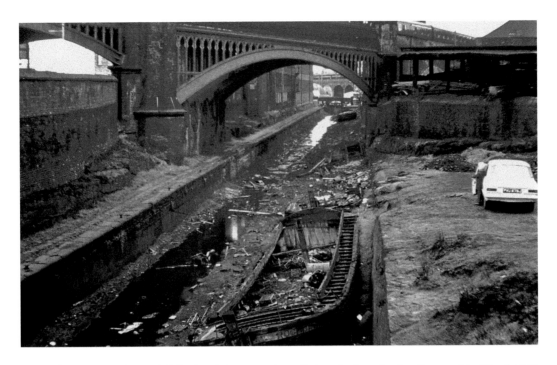

The remains of a Rochdale Canal Company boat lie beached on the derelict canal in March 1974 looking towards Castlefield. 'It seemed a very dark and menacing place,' says the photographer's son, who is seen next to his father's Ford Escort. (Alan K. Crowther)

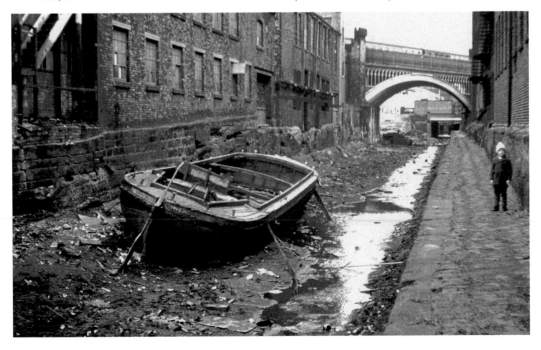

The area around Knott Mill in central Manchester in March 1974. The abandoned boat is *Christine*, once the proud property of Albert Blundell and numbered 153. Who would have thought this would be a vibrant waterway thirty years later? (Alan K. Crowther)

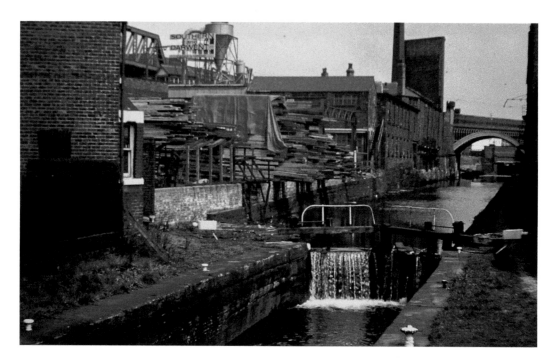

This is Lock 92 on the disused Rochdale Canal looking towards Deansgate Tunnel in Manchester on 20 June 1989, with the Manchester South Junction & Altrincham Railway passing overhead in the distance. (Alan K. Crowther)

A diesel locomotive crosses the canal in 2022, viewed from the bridges above Deansgate. (John Evans)

This rather unprepossessing bridge – almost a hole in the wall – marks the end of the Rochdale Canal. Directly behind it is Lock 92, with Beetham Tower on the left. (John Evans)

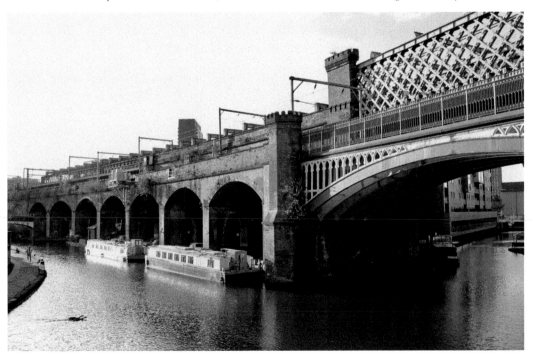

At last we have reached Castlefield Basin, where the Rochdale Canal joins the Bridgewater Canal in central Manchester. (John Evans)

Bibliography

Dickens, C., *Hard Times* (Oxford: Oxford World's Classics, 2005)

Gibson, K., *Pennine Pioneer* (Stroud: The History Press, 2014)

Hadfield, C., and Biddle, G., *The Canals of North West England Volume 2* (Newton Abbot: David & Charles,1970)

Lower, J., *The South Pennine Ring* (Sheffield: The Hallamshire Press, 1998)

Taylor, M., *The Canal & River Sections of the Aire & Calder Navigation* (Barnsley: Wharncliffe Books, 2003)

Quinlan, R., *Canal Walks: North* (Stroud: Alan Sutton, 1993)

Rolt, L. T. C., *Narrow Boat* (Stroud: Alan Sutton Publishing, 1994)

Waterways Guide 5, North West & the Pennines (Glasgow: Nicholson, 2019)

Rochdale Canal – How the Work Was Done, *Rochdale Observer* http://www.rochdaleobserver.co.uk/community/canal/how_the_work_was_done/s/500/500129_reopening_was_easy__all_we_needed_was_some_cash.html. (Accessed 31 March 2022).

www.28dayslater.co.uk

www.avroheritagemuseum.co.uk

www.britishlistedbuildings.co.uk

www.canalrivertrust.org.uk

www.historicbridges.org

www.penninewaterways.co.uk

https://sites.rootsweb.com/~todmordenandwalsden/woodhousemill.htm

www.visitcalderdale.com

www.youtube.com